Little Germany on the Missouri

UNIVERSITY OF MISSOURI PRESS COLUMBIA AND LONDON

Little Germany on the Missouri

THE PHOTOGRAPHS OF EDWARD J. KEMPER, 1895-1920

Edited by Anna Kemper Hesse

Printed from the Original Glass-Plate Negatives by Oliver A. Schuchard

Erin McCawley Renn, Adolf E. Schroeder, and Oliver A. Schuchard, Contributing Editors

Library of Congress Cataloging-in-Publication Data
Kemper, Edward J.
Little Germany on the Missouri : the photographs of Edward J.
Kemper, 1895–1920 / edited by Anna Kemper Hesse ; Erin McCawley
Renn, Adolf E. Schroeder, and Oliver A. Schuchard, contributing editors.
 p. cm.
"Printed from the original glass-plate negatives by Oliver A. Schuchard."
Includes bibliographical references and index.
ISBN 0-8262-1205-0 (alk. paper)
1. Hermann (Mo.)—History—Pictorial works. 2. Hermann (Mo.)—
Social life and customs—Pictorial works. 3. German Americans—
Missouri—Hermann—History—Pictorial works. 4. German Americans—
Missouri—Hermann—Social life and customs—Pictorial works.
I. Hesse, Anna. II. Title.
F474.H5K46 1998
977.8'61—dc21 98-23340
 CIP

Designer: Stephanie Foley
Printer and binder: Walsworth Publishing Company
Typefaces: Bembo and Carlton

This book has been published with the generous assistance of contributions from The Brush and Palette Club, Inc.; the Deutschheim Association of
Hermann, Missouri; the Gasconade County Historical Society; Mr. and Mrs. Jim Held of Stone Hill Wine Company, Inc.; Hermannhof Winery, First
Bank; the Pepsi Cola Bottling Company of New Haven, Missouri; and Randolph and Lois Puchta of Adam Puchta Winery.

To our fathers and forefathers, in deep gratitude for what they left us—
the land they treasured, the crafts brought from Europe and adapted, the
family and community ties established, the celebration of church, school,
home, and nation, the spirit of caring and neighborliness.

ANNA KEMPER HESSE

Therefore when we build, let us think that we build forever. Let it not be for present delight alone nor for present use alone. Let it be such work that our descendants will thank us for, and let us think, as we lay stone on stone . . . that men will say as they look upon the labor and the substance of them, "See! This our fathers did for us!"

JOHN RUSKIN

Contents

I

Building Hermann
A BALANCE OF MANUFACTURING AND AGRICULTURE

Descriptive List of Photographs

Preface

The artistry of two gifted photographers, born more than a half century apart, converge in this historic collection of photographs recording day-to-day activities in a Missouri German American community balanced between its old and new cultures. A noted horticulturist and viticulturist, Edward J. Kemper has also become known for the photographic record he left of life in Hermann, Missouri, at the turn of the century. Oliver A. Schuchard, an internationally known contemporary photographer, has recaptured the world that Edward Kemper preserved in glass-plate negatives and original prints. Himself a German American, born in St. Louis, Schuchard responded to Kemper's eloquent visual realization of "the essence of Hermann" and strove to remain true to the original vision.

The Kemper photographs provide a series of evocative pictorial essays on life in Hermann and its environs in the years preceding and during World War I. Located seventy miles west of St. Louis, Hermann was planned in 1836–1837 by the members of the Philadelphia Settlement Society in Pennsylvania as a colony in the "Far West" that was to be "German in every particular." Its founders were primarily new immigrants from Germany who wanted to shield their children from the Americanization and erosion of language and traditions that had occurred among the older German immigrant groups in Pennsylvania. The colony's unique character as a nineteenth-century immigrant settlement was due partly to the objectives of its founders, and partly to the diversity of the geographical and social origins of its early settlers, who came to the isolated Missouri River area from many regions of German-speaking Europe as well as from German enclaves in a number of North American cities. Because no single regional, religious, or philosophical orientation was represented in the colony, it drew settlers with a broad range of aspirations and beliefs. Their common vision was based almost solely on their clearly articulated commitment to the perpetuation of their culture through the preservation of the language, traditions, and values of their European homeland.

The success with which they were able to achieve their vision was made possible by the varied talents and skills of the colonists, which enabled them to build the foundations for the golden age of economic prosperity and cultural vitality enjoyed by their descendants at the turn of the century. Although it shared some of the characteristics of other German immigrant communities in the Midwest, Hermann had many qualities without parallel elsewhere. The area's remarkable economic prosperity was largely based on the concept, established in Philadelphia, of a balance of manufacturing and agricultural enterprises, and particularly on the grape and wine industry developed by a first and second generation of self-trained viticulturists.

The importance of the Kemper photographs, which capture life

in Hermann during more than two decades of cultural, economic, and social change, lies in their evocation of a vital yet fragile and threatened cultural microcosm in the Midwest at the turn of the century. Although the founders of the colony made sustained efforts to develop a unique environment for themselves and their descendants, Hermann was ultimately unable to withstand the encroachment of outside influences. Even as the settlers and their descendants imposed the town plan made in Philadelphia on the frontier site and transformed the hills and valleys of the settlement into productive vineyards and wineries, the German colony they established and nurtured was inevitably developing into an American German community. A subtle blending of the New and Old Worlds had occurred in the architectural, social, and cultural landscape of the town and its environs at the height of its economic achievement. Edward Kemper's photographs document the processes of the changing cultural balance that took place in the Hermann community in the early twentieth century.

Hermann's era of prosperity came to an abrupt end with Prohibition. The cultural activities that fostered its ties to European tradition had been weakened as the use of the German language in church, school, and community was discouraged by energetic national and state efforts during World War I. "To eliminate enemy language and influences" was a major function of the Missouri Council of Defense. The Kemper photographs, therefore, offer a unique insight into a time and place still reflecting strong influences of a German heritage that was destined to decline inexorably as the twentieth century progressed and the cultural, economic, and social environment was altered by historical events over which the community had no control.

The arrangement of the book into three sections allows the reader to explore major aspects of German American culture manifest in Hermann during its golden age. The first section, focusing on the work life of the town and the surrounding farms and settlements, reflects the European origins of the early settlers, demonstrated not only in the townscapes but in the habits and practices in the outlying communities. The second section brings together photographs relating to the vineyards and wineries, documenting community participation in the work of developing the grapes and wines on which Hermann's prosperity was based as well as the celebrations marking the completion of seasonal tasks relating to grape culture. The photographs in the third section evoke traditional family and community life, both in the town and in the rural areas surrounding Hermann.

A short biography of Edward J. Kemper, a historical introduction to Hermann, and special commentaries on the photographs introduce the three photographic sections, which include remarks and commentary by editor Anna Kemper Hesse, the youngest daughter of Edward Kemper; photographer Oliver A. Schuchard; and cultural historian Erin M. Renn.

Acknowledgments

My special thanks to Laura Bullion, Assistant Director, and Nancy Lankford, Associate Director, of the University of Missouri Western Historical Manuscript Collection, Columbia, for their help and patience as I worked to identify places and people in the Edward J. Kemper photographs. Special thanks also to Lois Hoerstkamp Puchta for her assistance in preparing the original manuscript.

ANNA KEMPER HESSE

Anna Hesse deposited the Edward J. Kemper collection of nearly two hundred glass-plate negatives in the University of Missouri Western Historical Manuscript Collection in Columbia in 1985 to ensure that her father's visual record of the Hermann environment would be preserved. A grant from the Missouri Humanities Council and the National Endowment for the Humanities to the Brush & Palette Club, Inc., in Hermann partially supported the reproduction of selected photographs from the original glass-plate negatives and early prints. An exhibit of Kemper photographs, "A Golden Age of German American Culture: Hermann, Missouri, 1895–1920," was produced in cooperation with the Missouri Department of Natural Resources,

Division of State Parks, as part of the Museum Traveling Collection. It is on exhibit at Deutschheim State Historic Site in Hermann.

On behalf of Anna, I would like to thank Erin McCawley Renn, Administrator, Deutschheim State Historic Site, Missouri Department of Natural Resources, Division of State Parks, for her invaluable advice and help in preparing the final copy of the manuscript of *Little Germany on the Missouri*. Her documentation of Hermann's agricultural and building practices, her interviews relating to Edward Kemper's last years, and her expert analyses and descriptions of the photographs have contributed substantially to the value of the book.

Special thanks are also due to Oliver A. Schuchard, Professor of Art, University of Missouri–Columbia, who brought an artist's eye and understanding to the challenge of printing the photographs from the Kemper glass-plate negatives, many now a century old. We are grateful for the dedication he has brought to the preservation of the photographs for future generations and the artistry and care he devoted to his work in this unique collaboration of artists who never met.

We appreciate the help of Linda Walker Stevens, who has shared her extensive knowledge of the life and work of George Husmann and her research on Hermann's grape and wine industry, making it possible for us to avoid many errors. The commitment of Rebecca B. Schroeder to the book has been constant. We are grateful to her and to Horace and Charles Hesse, Lois Hoerstkamp Puchta, Randy

Puchta, and others who have provided information we might otherwise not have had. Special thanks must go to the University of Missouri Press, which has dedicated the impressive talents of its editorial, design, and production staff to bring Anna Kemper Hesse's important work to completion. This is a moment her family and friends have long awaited.

Any errors that might have occurred in the preparation of the text for publication are the responsibility of the undersigned.

ADOLF E. SCHROEDER

Little Germany on the Missouri

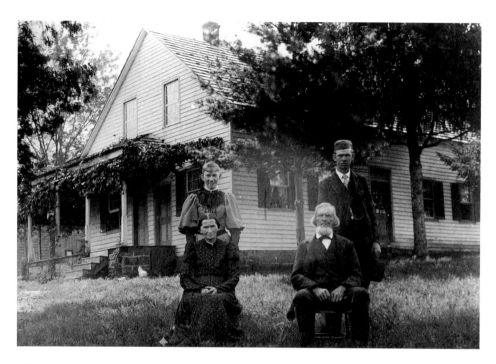

Christoph Kemper, Johanna Berger Kemper, Edward, and Johanna

The first photograph Edward Kemper made with his new camera was of his parents, his sister, and himself in front of their home. Christoph Kemper was living in his first home, a one-room structure of walnut logs, when he and Johanna Berger married in 1855; he rode his only horse to her home in Drake for the wedding. The couple returned to the Kemper farm on the Old Iron Road riding double. When they reached the log home, Johanna had one question: "But where is the house?" Eventually Christoph, with the help of his brother Simon, added seven additional rooms and two hallways to the log house.

Five sons and four daughters were born to Christoph and Johanna Kemper. By the 1890s, the older children had left Kemperhof to establish homes of their own. Only Edward and his sister Johanna remained, and when their father died in 1896, Edward took over the farm and nursery.

Edward J. Kemper

ANNA KEMPER HESSE AND ADOLF E. SCHROEDER

Edward J. Kemper—businessman, nurseryman, viticulturist, inventor, and photographer—was born in Gasconade County, Missouri, in 1871, the eighth of nine children of Heinrich Christoph Kemper (1818–1896) and Johanna Berger Kemper (1835–1904). In 1848 Christoph, as he was known in Hermann, son of Toens and Anna (Rehm) Kemper, Hof No. 11, Schoenemark, Lippe-Detmold, had decided to immigrate to America. Information on the heavy hand-made chest that held his belongings shows that he came "Über Bremen, nach New Orleans, nach St. Louis": from St. Louis, he came to Hermann.

Seven of the nine children of Toens and Anna Kemper left their home in Lippe-Detmold to come to the American Midwest. Four of the brothers, Simon, Johann (John), Friedrich (Frederick), and Christoph, decided to stay in Hermann. Frederick and Christoph soon bought land in the upper region of the west valley of Frene Creek, where they each planted two acres in grapes. After planting his vineyard, Christoph, realizing the potential demand for wine barrels, went to Cincinnati to learn the cooper's trade. John, trained as a miller in Germany, found employment at the Widow Tugel's mill on Big Berger Creek. Simon, the oldest, returned for a time to New Orleans but later settled in Hermann, where there was a great demand for his skills as a woodworker and *Tischler*, or cabinet maker. Each of the Kemper sons had learned a trade in Germany, and their skills proved invaluable in their new homeland. Three members of the Kemper family who came to the United States did not settle in Hermann; Heinrich and Bernhard Kemper went on to Iowa and bought land at Pine Mills and Muscatine. Their sister Louise settled with her husband, Henry Wellner, in New Ulm, Minnesota.

Edward Kemper lived all his life on *Kemperhof*, as the family called the farm that Christoph Kemper established an hour's buggy ride from Hermann. He received his sparse formal education in the one-room Coles Creek School, which was built adjacent to the

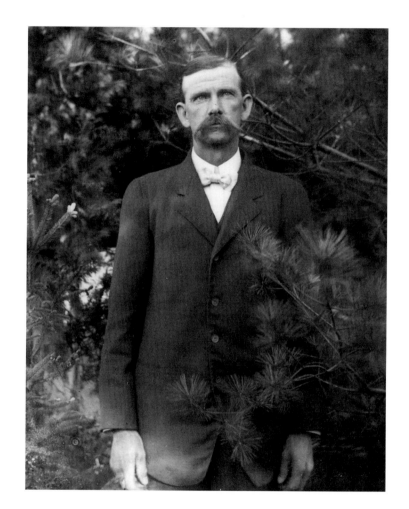

Self-Portrait of Edward Kemper

As with the group photograph of his parents, sister, and himself, Edward made this self-portrait by setting the camera on delayed shutter release and then running to stand in front of it. Kemper experimented with this technique several times. This photograph, one of the first he produced, dates from before 1900. The spruce trees in the yard were planted by Christoph Kemper with seeds brought from Germany.

Kemper farm in 1874. Often as many as sixty children, ranging in age from six to twenty, attended the school, where the curriculum was in German and strictly limited to reading, writing, and arithmetic. Although the educational opportunities in the Coles Creek School in no way matched the amenities available in Hermann itself, Edward Kemper grew up in a period in which the German cultural and social life and the economic prosperity envisioned by the members of the German Settlement Society of Philadelphia were being achieved.

In the year he was born, his father had invented and patented a feed cutter for chopping corn stalks, which made farm chores a little easier. Nevertheless, there was still much hard work to be done on the Kemper farm and in the vineyard. In his youth, Edward learned his skills not through a formal apprenticeship, as his father and uncles had done in Germany, but through working with his father, brothers, and neighbors. He was especially successful in raising grape plants for his neighbors, and from an early age he took part in the efforts of the grape-growing industry upon which Hermann's prosperity in the late nineteenth and early twentieth centuries was largely based. He kept in touch with the eminent viticulturist George Husmann by mail and worked with other prominent grape growers in the area who were trying to develop more vigorous, productive, and disease-resistant varieties of grapes and to promote the sale of Hermann wines.

In 1897 Kemper took over his father's grape-growing business, renaming it the Hermann Grape Nurseries. In 1900, at the urging of George Husmann, he went to the University of Missouri in Columbia to learn more about propagating and developing new varieties of grape plants that would be disease resistant, leaving his nursery, which required year-round care, in the hands of his brother-in-law and neighbor, Frank Stoehr. He soon found that the Hermann viticulturists had taught themselves skills not yet known to the experts. An academic experience he remembered and recounted years later occurred in one of his first classes: a professor advised the students that Norton's Virginia Seedling could not be grown from cuttings. Edward protested that he had been growing Virginia Seedlings from cuttings for over five years. When he later had catalogs printed for his Hermann Grape Nurseries, he advertised "Norton's Virginia Seedlings Grown From Cuttings, a Speciality" on the covers.

Although he took other courses while at the university, his interest in horticulture was always foremost. Inserted in one of the compositions for his German class is information about controlling the peach borer. Also, the habit of frugality taught to the sons and daughters of the early German immigrants can be seen in the careful record he kept of his expenditures at the university during the winter and spring of 1900. The entries show that an overcoat cost $19, two pairs of pants, $1.85, and socks, 15 cents. He contributed $2 to the church, practicing the values he had learned in the Kemper home.

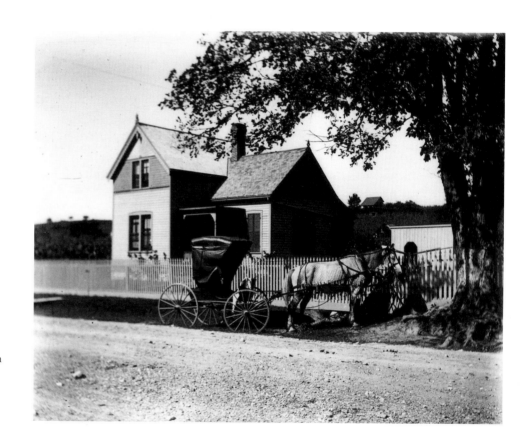

Courting Anna Gaebler

When neighbors saw Edward Kemper's horse and buggy in front of the home on Goethe Street where Wilhelmine Ronneburger Gaebler had moved with her youngest daughter after her husband died, they knew he was courting Anna.

In 1901, after completing his courses at the university, Kemper and his best friend, Hermann vintner Henry Sohns, took some of the grape plants from the Kemper Hermann Grape Nurseries to the Pan American Exposition in Buffalo, New York. (Edward's account for the trip indicates that he bought a new shirt for $1 and a necktie for 50 cents). The grape plants received an Honorable Mention, and the men explored all the buildings at the exposition, visited Niagara Falls and Niagara Glen, and photographed the boats on Lake Erie. They also visited the Finger Lakes district of New York State, where German varieties of wine were produced, and marveled at the lakeside vineyards on the steep, stony slopes and the success of the Elvira and Diamond grapes there.

In 1902, Edward Kemper married Anna Gaebler, granddaughter of one of Hermann's earliest settlers. Anna's paternal grandparents, Wilhelm (1799–1860) and Elisabeth Naumann Gaebler (1801–1854), and their three sons, Franz (1824–1902), Frederick or Fritz (1825–1893), and Ernst (1829–1910), came to Hermann in 1839 from Spora, Saxony, via Canada. They had bought a share in the Philadelphia Settlement Society in Montreal for $25. After their arrival in Hermann, they bought land and built a home in the Coles Creek Valley. Although Elisabeth was so ill she could not walk, the family moved into their new home in early December in the year of their arrival. Jacob Naumann, Elisabeth's brother, described the move:

At this time, no road, not even a prepared footpath, existed to their place. There was no other way to manage but to carry the chests and all the things which had to be transported tied between two poles with one man walking in front and the other behind. The move took place for five miles over narrow paths along the steep Missouri bluffs, over precipitous cliffs, over tree trunks and boulders and deep ravines.

When the household goods had been moved, Naumann helped to move his sister over the icy ground "on a contraption rigged for this purpose."

The Gaeblers' second son, Fritz, built his own home at First Creek after service in the U.S. Army and a trip to the gold fields of California. Anna (1880–1968) was the youngest of his eleven children.

Together, Edward and Anna Kemper developed the Hermann Grape Nurseries into a thriving business that shipped thousands of grape cuttings to customers throughout the United States and beyond. Through his research and horticultural successes, Kemper's name and nursery became well known in Europe and Mexico as well as in the United States and Canada. One of Edward Kemper's achievements was the development of the Aroma, a red-wine grape, which he described as aromatic, disease-resistant, and heavy-bearing. From a family of skilled artisans and inventors, he continually experimented

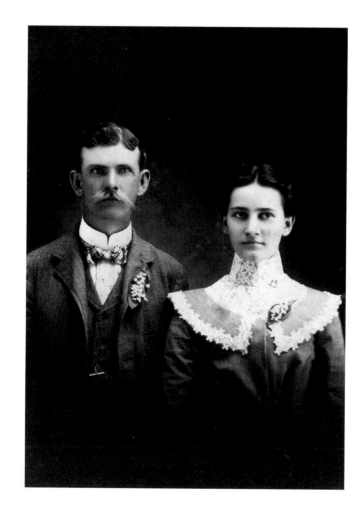

Newlyweds

Edward Kemper and Anna Gaebler, who had met at St. Paul's church, where both sang in the choir, were married on August 7, 1902. Edward's mother continued to live in the old house at Kemperhof, and Edward added three rooms for himself and Anna.

with technological and other farm improvements, inventing a riding grain drill that was bought by the John Deere Company. His home was one of the first in the area to have running water, accomplished by installing a gravity water system connected to the well at the bottom of the hill on the Kemper homestead. Water was pumped from the well into a large cistern with a one-cylinder engine, invented by his older brother, and then piped into the house from the cistern.

Kemper became interested in photography in his early twenties, and in 1895 he bought his first camera from the Rochester Camera Company in New York, a Kodak with glass plates and lens by Bausch and Lomb. With it he not only recorded family and neighborhood events but captured in detail the changing city and farm life around him. He was often called upon by his neighbors when they needed photographs. The 1913 *Standard Atlas of Gasconade County* contains over twenty of his careful compositions. In about 1914, he bought a No. 3-A Folding Automatic Brownie with Autographic Film No. 122 and made postcards to send to relatives, friends, and customers. His photographs served to promote his and other businesses in Hermann as well as to bring pleasure to himself and his subjects.

In 1919, the Eighteenth Amendment brought about national prohibition and put an end to the wine industry. The demand for grape cuttings dropped, and Edward Kemper turned to the examples of his father, who had developed an orchard with seeds brought from Germany, and his mentor George Husmann, who had established a well-known fruit tree farm and nursery business in the 1850s. Kemper turned to planting orchards and growing fruit trees with the energy he had devoted to his vineyards, changing the name of his Hermann Grape Nurseries to Kemper Orchards. In his apple orchard, he had Jonathan, Grimes Golden, Winesap, Red and Yellow Delicious, and the piquant Lady Apple, the favorite of many. For city yards, he provided apple trees that had two or three different varieties grafted on one tree. He entered his fruits and flowers in competition at the Missouri State Fair, the Gasconade County Fair, and the Hermann Garden Club for many years and won numerous awards and prizes. Still, his catalog for his new business noted that his trees and fruit were of superior quality because they were "grown on land rich enough in iron to produce Norton's Virginia to perfection." He also grew evergreens, shade trees, and flowers in his former vineyard. He had always practiced diversified farming, and he continued to grow corn and hay and raise livestock. An undated clipping from the *Hermann Advertiser-Courier* reported that "Ed Kemper marketed a 540-pound hog at the National Stock Yards and received a check for $68.85; several such hogs at that price would pay for a nice bottom farm."

Kemper Orchards became widely known for its excellent fruits, attracting buyers from throughout the state, and the products of the nursery won many blue ribbons at Missouri State Fairs, but it was hard to make ends meet in the 1920s

Kemper Cemetery

Johanna Berger Kemper died in 1904, and the following year Edward Kemper took this photograph of his parent's decorated graves and wrote on the back of the photograph:

Heute sind es Fünfzig Jahre, dass Vater und Mutter hierher kamen, wie wird's nach Fünfzig von jetzt sein? Hoffentlich alle in einer Besseren Heimat.

Hermann, Mo. Sept. 21.ten 1905

Today fifty years have passed since Father and Mother came here; how will it be fifty years from now? Let us hope all [will be united] in a better land.

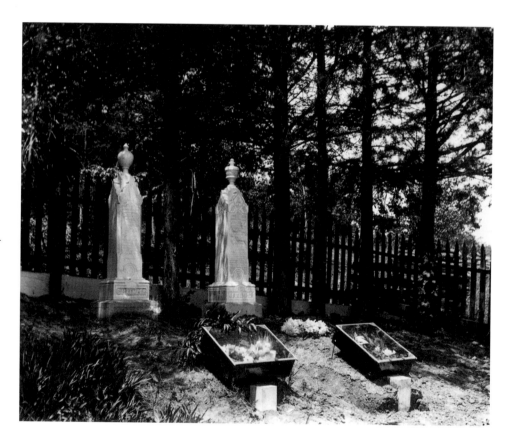

and 1930s. Kemper's wife and three daughters, Edna, Esther, and Anna, milked the cows and sold butter in town. They made their own cheese, and the children hunted for hickory nuts and hazelnuts that grew wild along the fencerows and in the woods. Like most farm families, they always had a garden for fresh fruits and vegetables to eat in the summer and preserve for the winter. In addition, there was sauerkraut in the basement to eat with stored potatoes.

Perhaps because photographs became more commonplace as many Hermann residents acquired cameras of their own, perhaps because of the economic hardships brought to grape growers by Prohibition, Kemper's photographic experiments stopped in the early 1920s. As the girls grew up, Edna and Esther went to St. Louis to work and Anna, *die Kleine,* stayed on the farm and helped with the orchard and other crops. When she married in 1935, she and her husband, Clarence Hesse, took over the nursery business for several years. Kemper had continued to grow some grapevines for the European market, and when Prohibition was repealed in 1933 he returned to wine making on a small scale, enthusiastic about the prospect of grapes and wines for the Hermann economy. The *Advertiser-Courier* of August 25, 1939, reported that

> Edward Kemper, who propagated vines for the famous vineyards of Hermann, has retired after forty-two years of Nursery work, but he is so enthusiastic about the Missouri Riesling that he planted a small vineyard this season. Kemper, who is seventy years old, has seen this small white grape attain great popularity and then fade into obscurity. He believes it could easily be used as the foundation variety for again establishing a wine industry.

Kemper's career as a viticulturist came full circle, but the Hermann wine industry, destroyed by the fourteen years of Prohibition, would not achieve the vitality of its early years for almost a quarter of a century.

Horace Hesse, Kemper's grandson, began to help him with the farm and orchard during the 1940s and before he was ten could harness, hitch, and drive mule teams. He remembers that there was always work to be done, in the orchard and in the fields. His grandfather still preferred to speak German in the family, and although he spoke English easily, he always gave instructions to Horace and to the farmhands in German. He was formal, dignified, and usually serious with children, but he could be full of jokes and laughter with his friends. He was known as a good neighbor in times of crisis, and his neighbors also helped him. In spite of being an inventor of some skill, he was noted for being inept with certain kinds of mechanical things, and as he grew older, a neighbor had to stop by every morning to start his tractor and generator, a chore later taken over by a hired hand.

For Christmas 1951, Anna Hesse taught her younger son, Charles, then three, to sing "O Tannenbaum" in German as a special gift to her father. According to Horace, his grandfather was so delighted he broke into a rare, spontaneous grin.

Edward Kemper died less than three weeks later, on January 12, 1952, shortly before his eighty-first birthday, after a brief illness. He was buried in the cemetery on the Kemper farm, which he had designed. The entrance he built is flanked by two columns constructed of different Missouri rocks he had collected as he traveled around the state and topped with geodes.

Edward Kemper's attributes—artistic in nature, inventive, hard-working, an entrepreneur throughout his life—enabled him to make substantial contributions to his community. Not the least significant of these contributions is his collection of photographic images documenting life in Hermann and its surrounding rural communities during a generation of change. By photographing his neighbors in their everyday settings, he has preserved an aspect of American cultural and social history from 1895 to 1920 that has rarely been recorded.

Anna Kemper Hesse on the Kemper Farm

After her sisters married and moved away, Anna Kemper remained on the farm where she helped with the orchard and other crops. She learned to graft trees and later grew an apple tree in her yard in Hermann that bore several varieties of apples.

Hermann—A Brief History

ADOLF E. SCHROEDER

The history of the founding and settlement of the Hermann Colony in Missouri is in many ways unique, but its origin and development reflect important aspects of the German immigrant experience in America. The aspirations of its founders were not unlike those of many of the educated emigrants who left Germany in the 1830s and were drawn to Missouri by Gottfried Duden's *Report*.[1] Through a fortuitous convergence of talent and opportunity, however, as well as an unswerving dedication to the preservation of their cultural identity, the Hermann colonists eventually saw the achievement of the collective as well as the individual goals of their members. An earlier group, whose members founded Dutzow in Warren County in 1833, had promoted the idea of a German colony in Missouri, but their plan did not succeed in drawing the necessary new settlers. Other societies suffered a similar failure of their collective aspirations. The leaders of the Giessen Emigration Society, Friedrich Muench and Paul Follenius, had hoped to found a German state in the Far West, but the group broke up on arrival in St. Louis in 1834, and individual members settled in different parts of the state. The same fate befell the members of the Solingen Emigration Society, led by Friedrich Steines. Although many individual members of the emigration groups arriving in Missouri in the 1830s achieved a prominence that enabled them to make valuable contributions to the economic, political, and social development of their adopted state, only the Deutsche Ansiedlungs-Gesellschaft zu Philadelphia, the German Settlement Society of Philadelphia, founded in Pennsylvania on August 27, 1836, for the purpose of establishing a German colony in the Far West, was able to build the little city on the Missouri

1. Gottfried Duden, *Bericht über eine Reise nach den westlichen Staaten Nordamerikas's und einen mehrjährigen Aufenthalt am Missouri (in den Jahren 1824, 25, 26, und 1827), in Bezug auf Auswanderung und Uebervölkerung.*

frontier that Duden had envisioned a decade earlier as a haven for his oppressed countrymen.

> If a small city were founded with the intention of serving the American Germans as a center for culture, one would soon see a rejuvenated *Germania* arise and the European German would then have a second country here.... No plan of the present day can be more promising to the individual and to the whole than such a plan for the founding of a city as the center of German culture in Western North America....[2]

The organizers of the German Settlement Society of Philadelphia, for the most part recent immigrants from German-speaking countries, had not found the environment they had sought in Philadelphia, even though thousands of their countrymen had settled in Pennsylvania since the landing of the *Concord,* the "German Mayflower," in 1683. As early as 1732, Benjamin Franklin had established a German newspaper to serve the increasing numbers of immigrants, and by the 1750s, he was complaining that Pennsylvania was becoming a German colony. It had an estimated 150,000 residents of German origin by 1800, but the new immigrants of the nineteenth century, imbued with the romantic notion then prevailing in Germany that everything German should be preserved, found the descendants of the earlier settlers distressingly Americanized, having lost some or all of the language and traditions the newcomers treasured. Friction arose between old immigrants, who were content with their Americanized lifestyles, and new immigrants, who wanted to preserve the language and traditions of their homeland through German newspapers, German schools, and German customs and practices. Like many nineteenth-century immigrants, these newcomers had not come to America to see their children lose their language and customs. They had expected to find in their new country the freedom and economic stability necessary to ensure the preservation of their culture. Many prospective and new immigrants became convinced that only by settling in a new and isolated location in the western United States could they safeguard all things German, create a more favorable environment for future generations, and at the same time enjoy the rights and privileges of their newly adopted country.

The first published notice concerning the plan to organize a group to establish a German colony in the West appeared on May 7, 1836, in the Philadelphia German-language newspaper, *Alte und Neue Welt.* Edited by J. G. Wesselhoeft, who was to become an officer in the German Settlement Society, the paper had been founded in January 1834. Wesselhoeft not only wanted to encourage Germans to maintain their mother tongue but also hoped to unify them into an influential political force. The announcement regarding the

2. Quoted from the first complete English edition of Duden, *Report on a Journey to the Western States of North America and a Stay of Several Years along the Missouri,* ed. James W. Goodrich, et al., 179.

proposed colonization plan invited all "noble-minded, reasonable, and industrious people" who were committed to the preservation of German culture to a May 21 meeting in Commissioners' Hall.[3] The meeting had to be postponed because of a scheduling conflict, but was eventually held on June 3. No record of its proceedings is known to exist, but it can be inferred from subsequent events that the plan was well received and that a working committee was appointed to develop a constitution. At its first meeting, held on June 10 in the Penn Hotel, the committee chose Pastor Heinrich Ginal as its chairman.

Reverend Ginal seems to have entertained the hope of creating a Christian communal settlement patterned after George Rapp's Harmony Society, which had been founded in 1805 in Butler County, Pennsylvania. After moving to Indiana in 1814, the Harmonists had returned to Pennsylvania in 1825 and established the town of Economy on the Ohio River near Pittsburgh. The prosperity the Harmonists had achieved and the rich cultural life they enjoyed were well known, but Ginal's proposal was rejected in favor of establishing a settlement based on a free-enterprise system in which manufacturing and agriculture would go hand in hand to provide economic balance and as much self-sufficiency as possible.

As new immigrants to the land of freedom and opportunity, the society's leaders were concerned from the beginning with providing safeguards to prevent those with the most capital from gaining control of the organization. The colony was to be established "by the people, for the people," and the absolute equality of the rights and privileges of all its members was to be guaranteed. To accumulate the necessary capital, the founders decided to form a stock company and offer shares in the German Settlement Society, with each share entitling the purchaser to a lot or a forty-acre farm in the proposed settlement and partnership in the capital of the society and its future community buildings and factories. Plans were made to ensure that those without sufficient means to purchase shares would be able to obtain them by working in the colony.

After considering many proposals and suggestions, the leaders worked out a constitution. It was submitted to the membership and formally accepted on August 27, 1836, by 225 signatories. Within less than two weeks after the formal adoption of the constitution, 350 shares in the German Settlement Society had been sold at twenty-five dollars each, and the dream that a rejuvenated *Germania* might arise in the Far West seemed to be approaching realization.

Although aware in some measure of the difficulty of the undertaking they proposed, the organizers believed that their

3. Notice in *Die Alte und Neue Welt,* May 7, 1836, German quotation in William G. Bek, *The German Settlement Society of Philadelphia and Its Colony, Hermann, Missouri* (1907), 3-4 (translation mine).

knowledge of American conditions, customs, and laws would make it possible for them to succeed where ventures originating in Europe had failed. The planned settlement was promoted vigorously in Germany as well as in North America. Notices were placed in German newspapers in cities extending from Hamburg to Switzerland and from Elberfeld to Breslau. Pamphlets were printed to be distributed at all embarkation points. In America, where the colonization plan was widely publicized in the German American press, reaction was mixed. *Alte und Neue Welt,* which became the official organ of the society in September 1836, published letters both in favor of the plan and in opposition to it, leading to a controversial amendment to the constitution of the society providing that any member who criticized it could be expelled.[4] The *New York Staatszeitung* was bitterly opposed to the venture from the beginning, while the *Allgemeine Zeitung* of New York warmly favored the idea. In many American cities enthusiasm was high. A branch of the society was established in Albany, New York, as early as November 3, 1836, and auxiliaries subsequently formed in Baltimore and Pittsburgh. German residents of Montreal, Cleveland, Cincinnati, and New Orleans were particularly interested in the planned colony, and they ultimately constituted almost one-sixth of the shareholders.

4. This amendment caused a great deal of controversy as a restriction upon the freedom of speech guaranteed in the constitution of the United States, but there is no indication that it was ever enforced. See Bek, *German Settlement Society* (1907), 33-34.

After the society was incorporated by the State of Pennsylvania early in 1837, the next major concern was the selection of a site for the settlement and the acquisition of appropriate lands. One of the earliest locations under consideration was a large tract of over a hundred thousand acres in what later became Jefferson County, Texas. The proposal evoked considerable discussion but was soon rejected because of the concern that the newly independent Texas Republic might not be able to maintain the political and economic stability the organizers desired. In March 1837 Deputy C. G. Ritter was commissioned to go to Washington and confer with land agents, make inquiries at the government land office, and apply to Congress for information and assistance. One member moved "That the Society should attempt to appeal to Congress to sell as much Congressional land as the Society desired on credit." A Congressman from Philadelphia, a friend of the German Settlement Society, advised against this and it was voted down, but Ritter was sent "to confer with certain land agents, but more particularly to make inquiry at the government land office and even to apply to Congress for information and to actually appeal for assistance."[5] He returned with encouraging information (although he had not interviewed Congress), and three deputies, armed with detailed instructions, were dispatched to seek a suitable

5. Bek, *German Settlement Society* (1907), 30.

location for the settlement in the states of Indiana, Illinois, Michigan, Missouri, or Wisconsin. They were to arrange for the purchase of not less than twenty-five thousand acres of land.

Only three of the eagerly awaited weekly reports that the deputies had been instructed to submit were received in Philadelphia, and it was not until they returned on July 12 and prepared their final report, submitted on July 17, that details of their mission became known. The land located by the emissaries lay some ninety miles west of St. Louis along the Gasconade River, approximately five miles from its confluence with the Missouri. The accessibility of navigable rivers, the proximity of lead mining and iron ore, a favorable site for a city, and safety from flooding were attributes that combined to make the area a promising location for the colony. The physiographical variety offered terrain suitable for agriculture, viticulture, and animal husbandry, as well as an abundance of limestone for building. Although only the right bank of the Gasconade was suitable for settlement, the deputies recommended that land on both sides of the river be purchased, from its mouth for approximately nine miles, to avoid encroachment from other settlers.

Missouri was well known to Germans in Philadelphia because of the popularity of Gottfried Duden's *Report* and the work by Traugott Bromme, *Missouri eine geographische, statistische, topographische Skizze für Einwanderer and Freunde der Länder-und Völkerkunde,* published in Baltimore in 1835. Both writers had praised Missouri as a site for German settlement and colonization. Additionally, as Warrenton researcher Dorris Keeven has reported, Johann Wilhelm Bock, leader of the Berlin Society at Dutzow, had published a call for settlers to establish a German colony in Missouri in *Alte und Neue Welt* throughout 1835 and 1836. After consideration of the deputies' report on the site in Missouri, the German Settlement Society's Board of Managers decided to accept their recommendations and send an agent to purchase the land.

Board member George F. Bayer, a schoolmaster employed by the *Zions-Gemeinde,* a congregation in Philadelphia, was chosen to represent the society in the purchase, and on July 27, 1837, he set out for St. Louis with instructions to purchase the property the deputies had recommended for the settlement. By the time he arrived, however, Bayer was not able to acquire the land along the Gasconade selected by the deputies; only a few sections in that locality were still available. The major part of the purchases he made lay in individual parcels, for the most part contiguous, farther east, toward the present site of the town of Hermann, chosen for what he considered their suitability for agriculture or their promise for manufacturing. Altogether he acquired a total of 11,012.54 acres of government land at a cost of $14,077.54; he bought an additional 288 acres located along Frene Creek, seven miles east of the confluence of the Missouri and Gasconade Rivers, from private owners for $1,535. One settler refused to sell his property and subsequently

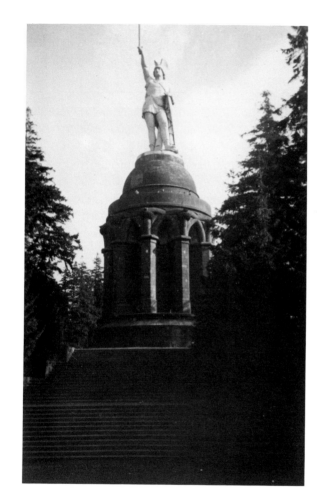

Hermann's Denkmal

Work on the monument in Westphalia commemorating the victory of the Teutonic warrior, who left the Roman Legion to oppose Rome's expansion eastward, was completed in 1875. The monument became a popular tourist attraction as nationalism increased in a unified Germany. (Photograph by A. E. Schroeder, circa 1932.)

became a source of irritation to colonists, who wanted to establish a settlement that would not only be German in every particular but also one over which they would have complete control.

The news that land for the colony had been purchased was enthusiastically received in Philadelphia. Prospects for the settlement looked bright in spite of the effects of the Panic of 1837. By September 7, 1837, 823 shares had been sold. At a meeting on October 5, a name was chosen for the planned city. It was to be called "Hermann," in honor of the old Germanic hero, the leader of the Cherusci, whose Teutonic tribesmen had defeated three Roman legions in the Teutoburger Forest in Westphalia in the year A.D. 9.[6] In the closing months of 1837 the Board of Managers, who saw Hermann as a future rival to St. Louis, developed the town plan, stipulating that Market Street be ten feet wider than Market Street in Philadelphia. They laid out and assigned building lots, named the streets for German literary and historical figures and American statesmen, and designated promenades and public squares. No butchering was to be allowed in the city, and no glue, turpentine, or other factories that endangered life or environment could be built in Hermann. The price of shares was raised to $35 as of October 1 and increased to $50 on December 1.

Seventeen persons—nine adults and eight children—left Philadelphia for Missouri as soon as the purchase of the property was announced.[7] They arrived at the desolate wilderness site on the Missouri River on the last boat of the season, December 6, 1837, to face a winter that they were able to survive only with the help of American settlers in the area. George Bayer, who had been appointed general agent of the society at a salary of $600 a year, set out from Philadelphia later in December, but he became ill in Pittsburgh and did not arrive in Missouri until late March 1838. He found extremely dissatisfied colonists and overwhelming responsibilities as he tried to establish a stable basis for the struggling settlement. Plans made in Philadelphia turned out to be difficult if not impossible to carry out on the frontier. Bayer was charged with overseeing everything relating to the development of the colony, including obtaining food and supplies for all residents, supervising the surveying of the entire acreage, assigning lots and other property to colonists and shareholders, and handling complaints. He was also to enforce the regulations that had been drawn up in Philadelphia regarding the

6. At the time the German Settlement Society of Philadelphia was established, plans were underway in Germany to build a monument to Hermann, the old Teutonic hero, on the Grotenburg in the Teutoburger Forest. The society's effort to honor the ancient hero reflected a growing nationalism in nineteenth-century Germany.

7. Conrad Baer; Georg Conrad Riefenstahl, with his wife and five children; Johann Georg Praeger, with his wife and two children; Gottlieb Heinrich Gentner, with his wife; and Daniel Oelschlaeger, with his wife and one child, were the first to arrive in Missouri.

construction of the buildings. Owners of town lots were required to have a building valued at three hundred dollars erected within a year or forfeit their property to the society.

During the spring of 1838 another group of colonists arrived in Hermann, and by the end of the year the number of new arrivals totaled 230. Of these, twenty-nine were unmarried men, and two were widows with three and five children respectively. Energetic promotional efforts for the colonization plan continued in Philadelphia. Five hundred notices were printed to be sent to relatives and friends of society members in Europe, and another five hundred were sent to European ports to be distributed on ships bound for North America. Offices were established in St. Louis, Cincinnati, and Louisville to encourage and facilitate the colonization effort. Glowing reports of the geographic advantages and financial stability of the Hermann colony continued to reach the officers of the society in Philadelphia, along with complaints about Bayer's conduct of his many duties. On June 2, 1838, the Board of Managers decided that Bayer's obligations were so heavy he could not carry them out; they proposed to transfer some matters relating to the administration of the colony to society members in Hermann, a plan Bayer opposed. He believed it was premature to expect self-government from the settlers. Throughout the troubled summer of 1838, however, the colonists continued to press for transfer of the management of their affairs and a public accounting of the financial status of the society. When his term

as agent expired in October 1838, Bayer was relieved of his duties, and a special committee of colony trustees assumed control of Hermann and took over the responsibility for conducting its financial affairs, making purchases, and handling the sale of shares.[8]

By the end of 1838, however, the trustees had still not received the legal authorizations and documents it needed from Philadelphia to carry out its obligations, and it became increasingly apparent that not all colonists wanted control of the society's affairs to be transferred to Hermann. Two factions had developed—one of mostly townspeople, who wanted separation from Philadelphia, and the other of those who had settled in outlying areas and feared that the incorporation of Hermann would disenfranchise members of the society living outside the city, depriving them of the rights and privileges promised them by the parent organization. With controversy and conflicting reports emanating from Missouri, society officers postponed the transfer of authority, sending Treasurer Adam Schmidt to determine whether the laws of Missouri permitted the rural population to have the same voting rights as residents of the town. Schmidt found no

8. The special committee, consisting of E. C. Staffhorst, Julius Leupold, M. Krauter, W. L. Henrich, W. Senn, and G. H. Gentner, was appointed and authorized to call a meeting with the general agent for the purpose of organizing the colonists and electing regular officials. See Bek, *German Settlement Society* (1907), 65.

law that would disenfranchise members of the society living in rural areas, and upon his return to Philadelphia, he urged the immediate transfer of authority to the Hermann colony. A committee was appointed to see how the transfer could best be accomplished. After a lengthy exchange of reports, meetings in Philadelphia and Hermann, and petitions and resolutions, the transfer was finally effected. At a meeting held on December 12, 1839, at the Penn Hotel, the German Settlement Society of Philadelphia was officially dissolved. At that time, some three and a half years after its founding, there were over 650 society shareholders, some with several shares, from forty towns in eleven states and Canada.

By the time the society was dissolved, at least a part of its goal had been achieved. Its colony, Hermann, had gained a foothold on the Missouri frontier. A letter of May 15, 1839, from G. W. Stühlinger, August Leonhard, and F. W. Pommer had reported enthusiastically on the progress made in the colony in spite of the many difficulties with which a new settlement on the western frontier had to contend. There was a population of 450 in the town and surrounding community. Ninety houses had already been built, and an average of a house per week of "frame or stone" was being completed. Streets had been laid out according to the plans made in Philadelphia (named for Goethe, Schiller, Mozart, Gutenberg, Washington, Jefferson, and others), and lots for Catholic and Evangelical churches had been selected. There were five stores, a cigar factory, two large inns, and a post office. A school building was under construction, a brass band *(Musik Chor mit Blech Instrumenten)* had been formed, and two companies of riflemen, each comprising fifty men, had been established.[9]

Yet in spite of such achievements, the artisans, intellectuals, farmers, and tradesmen who had seen the German Settlement Society plan as an opportunity to achieve a more prosperous and secure life for themselves and their children endured many disappointments, hardships, and tragedies to establish their settlement. George Bayer, disappointed by the distrust of fellow colonists, died on March 18, 1839. He was buried in the cemetery that he had laid out high above the Missouri River. There was illness in almost every household during the first years, and the settlers sometimes despaired for the future of the colony. One of the best reports of early immigrant life in Missouri was written by Jacob Naumann, who spent some time in Hermann in the late 1830s, visiting his two sisters, Mrs. Wilhelm E. Gaebler and Mrs. Michael Kroeber. He was contemplating settlement in Missouri, and his book, *Reise nach den Vereinigten Staaten von Nordamerika,* bears eloquent witness to conditions in the little colony when he arrived in 1839, about a year and a half after the first seventeen settlers had come to what historian William Bek referred to as a "howling wilderness." "In Hermann things looked sad at this time.

9. Bek, *German Settlement Society* (1907), 77-78.

Stonehill Winery

The walls of Stonehill Winery's sixty-by-sixty-foot main building are twelve inches thick. The cupola has a commanding view across Hermann and the Missouri River valley. Note the orientation of the front steps, which ascend alongside the building, a longstanding German preference seen throughout Central Europe and in many German American communities. The design was necessary in Germany, because buildings were placed to the edge of their lots, and continued in America. Built in 1869, the building is a fine example of German Vernacular architecture. (Photograph by Oliver Schuchard, 1991.)

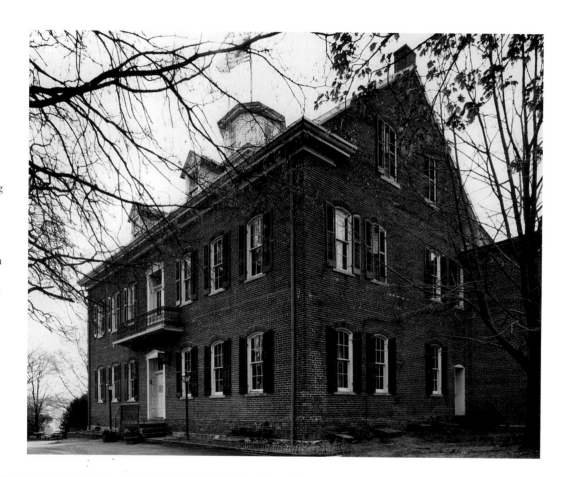

In most homes there was sickness, and more people took sick daily. Fever of all kinds raged, despondency and dejection resulted, and those not afflicted moved about like corpses."[10]

His description of the town agreed in some ways with that of Stühlinger, Leonhard, and Pommer, but he brought a more critical eye to the scenes that greeted him:

> When I arrived here about eighty houses had been built. Most of them were log cabins or small frame buildings, rather hastily erected, with a few of baked brick or stone in between. These houses or cabins stood scattered on a big plain along the future streets of the new town, the directions of which could not be determined because of the many felled tree trunks or the brush lying criss-cross everywhere. . . . At this time of the year there were almost daily terrible thunderstorms accompanied by pouring rain. The stream running through frequently flooded the low-lying areas of the place, and everywhere large puddles of water were left. Rotting wood and dead fish in the burning sun and ever-present humidity emitted a noxious air. . . . One could hardly wade through the deep muck which had developed there.[11]

Naumann agreed with those of the early settlers who complained that the location selected for the colony was unsuit-able for settlement because of the terrain—hills and valleys, steep bluffs, and narrow ravines. He speculated that the selection of the site may have been influenced by memories of ancient Rome, built on seven hills. "Presumably, however, they wanted to do Rome one better, for I believe that the place chosen for the city encompasses at least a dozen hills. . . ."[12]

Naumann's gift for observation and description is evident in his accounts of the living conditions, the illnesses, and the effects of the illnesses suffered by the settlers.

> Imagine a family recently emigrated [living with another] in a house which has only one single room that can be heated and which is barely enough for the needs of the owner and his family. And then when there is sickness in both families, and . . . this in the cold and unfriendly days of winter, and perhaps in a room which is in poorer condition than the shacks on the rifle range in our country, so that with the fire burning in the fireplace or the stove, the water standing in a bucket at the opposite wall freezes in a few minutes. Just imagine this, and it is not surprising that the people who are still well want a change at any cost. And it is still less surprising if a sick person, lying in bed, even discounting the physical pain, thinks of familiar conditions in the country left behind and with a longing for it which crowds the spirit and mind, succumbs to homesickness.[13]

10. Friedrich Bülau, ed., *Jakob Naumann's Reise nach den Vereinigten Staaten von Nordamerika, siebenjähriger Aufenthalt in denselben und Rückkehr nach Deutschland,* p. 215 (translations mine).
 11. Ibid., 212.

12. Ibid., 213.
13. Ibid., 222.

By his own account Naumann's attempts to adjust to the frontier were not successful. Although he acquired land, cut the trees for a log house, built the house with the help of neighbors, and even began clearing his land, progressing "with this miserable business . . . so far that I could begin making fence rails,"[14] he decided to give up plans to plant crops and instead look for paid work. In August he sold his place and after some teaching and further travel, he returned to Germany. As Anna Hesse grew up, she heard many stories from her Grandmother Wilhelmine Gaebler about "Uncle Naumann," who had not stuck it out in the new colony.

> Grandmother Gaebler came to live with us in the big house when I was eight. . . . As she told of the joys and sorrows of the immigrants . . . her stories would invariably include Uncle Naumann, her husband's uncle who tried many kinds of work and liked none, traveling here and there, never content to stay long in one place, but jotting down, painstakingly, everything that seemed of interest. And everywhere he traveled he took trunk and suitcase and gamebag—his *Bagage* as he called it. This became the standing joke in the family circle, and for four generations "Uncle Naumann's *Bagage*" was called to mind when someone traveled with many pieces of luggage.[15]

Jacob Naumann's sisters, their families, and other Hermann settlers who endured the hardships of the early years and remained in their frontier colony laid the foundation for the extraordinary economic prosperity and cultural vitality their descendants were to enjoy during the late nineteenth and early twentieth centuries. Early city leaders showed remarkable foresight in their policies. Citizens were paid with city lots for work done for the city, for building dams, digging wells, clearing trees and underbrush, and providing other needed services.[16] Many early settlers eventually prospered. Charles D. Eitzen, a native of Bremen who was to contribute substantially to the economic growth and cultural development of the town, had settled there in 1839. In 1841 he bought the store in which he had worked as a clerk and went on to become a leading merchant and lumber dealer. He also served as an agent for the Maramec Iron Works, which transported its iron by way of Hermann, contributing to the town's development as a major Missouri River port and to Eitzen's wealth.

In 1842, Hermann raised money to build a brick courthouse and became the county seat of Gasconade County. As early as 1844, the trustees of Hermann offered town lots for sale without interest to citizens who would plant the property to grapevines within five years. Terms for payment were

14. Ibid., 229.
15. Anna Hesse, ed., *My Journey to America, 1836-1843,* i.

16. Anna Hesse, *Centenarians of Brick, Wood, and Stone,* 5.

generous, and eventually six hundred lots were sold. George Husmann, whose work as a viticulturist and wine maker was to have an enormous influence on the American wine industry, planted his first vineyard on his father's property near Hermann in 1847.

Promotion of Hermann continued in the German and German American Press, regularly drawing new settlers to the colony, often German professionals and artisans as well as farmers and businessmen. When the German writer Franz Löher toured America in the mid-1840s he found that "in Hermann, which now has a population of almost 1,000 inhabitants, there is an active and happy German life and one feels at home there in the freedom of our fellow countrymen."[17]

From its earliest years, Hermann was characterized by an intellectual ferment and diverse cultural life rarely achieved outside large cities. As Anna Hesse has written, "Most of the early settlers . . . did not bring ax, rifle, froe or drawknife, but rather books, musical scores, brass musical instruments and printing press."[18] In July 1843, brothers-in-law Eduard Muehl and Carl Strehly moved from Cincinnati to Hermann, bringing their printing press with them, and a month later they published the first Hermann issue of the *Licht-Freund,* a biweekly newspaper that Muehl had established in Cincinnati in 1840. The *Licht-Freund,* the "Friend of Light," was the first German newspaper in Missouri published outside of St. Louis and continued to serve, as it had in Cincinnati, as a forum for Muehl's rationalist and liberal views. In his first months in Hermann, Muehl also organized a *Männerchor,* a men's singing society, and in 1844 he wrote to a friend in Cincinnati of his life in Hermann:

> Here in Hermann things are going very well. I love the free and easy ways one doesn't find in the big city. I live in a very small but convenient house. In the rear is a garden with fruit trees that I myself planted. . . . I have plenty of ham and greens, bread and sweet butter, and clear and fresh water.[19]

Although Muehl did not have much money, he reported that he had ample credit for his household needs. In less than a decade after its founding, it was possible to live well in the German settlement on the Missouri River, and Muehl was instrumental in further promoting Hermann to prospective settlers who wanted to live in the German environment that he evoked in his *Licht-Freund* editorials.

17. Franz Löher, *Geschichte und Zustände der Deutschen in Amerika,* 340.

18. Anna Hesse, "Notes from the Pageant: The Arts and Crafts of Early Hermann," n.d. Distributed at the Missouri Historical Preservation Meeting in Hermann, October 18, 1969.

19. Siegmar Muehl, "Eduard Mühl, 1800-1854: Missouri Editor, Religious Free-Thinker, and Fighter for Human Rights," 29.

[We] also observe our Sunday here, but of course not according to the English, but according to the German custom, *i.e.* not exclusively in Church or in the rocking chair, but in such a manner as our spirit and body find wholesome; therefore we also listen to a religious dissertation or read a book which appeals to us; but then we perhaps go hunting or fishing, converse amiably with each other in company, and every four weeks, on one Sunday evening, we go to the Theater, as *e.g.* last Sunday when "Hedwig" by Koerner was presented,[20] after which a dance was sensibly and honorably held. For the rest we let everyone celebrate his day as he wishes, be he Jew, Mohammedan, heathen, etc.[21]

Circulation of his paper was not improved by its move to Hermann, however, and Muehl and Carl Strehly established a new weekly paper, the *Hermanner Wochenblatt,* no less liberal in its views but somewhat more practical in its mission. Muehl continued his political and religious activism while promoting Hermann and its developing wine industry, which was beginning to draw attention throughout the area.

The education of their children had been a primary concern of the colonists, and as soon as the necessary clearing of lots and building of shelters was completed, their thoughts had turned towards establishing a school. The first classes, taught by George Bayer, were held in rented quarters, but in 1839 society member J. H. Koch donated a share of his property for a Hermann school, and a colony schoolhouse was built in 1839. Eduard Muehl was teacher and school supervisor for a time. Prospective teachers were rigorously examined to ensure their skills in German and English and their grasp of other subjects. In 1842 and 1847 land belonging to the society was deeded to the school district for an educational fund. On March 10, 1849, the Missouri General Assembly granted a charter to Hermann, sanctioning the use of the German language in instruction in all branches of science and education, and stipulating that the school was to be known as the "German School of Hermann" and that it "forever remain a German school."[22] In 1870 the legislature passed an amendment to the charter authorizing the trustees of the German School to impose a property tax to raise funds for a new school and in 1871 amended the amendment to authorize the issuance of bonds. The German School (now a museum) was built on Schiller Street in 1876, and as late as the first decade of the twentieth century German was taught in all grades. The high school curriculum included works by Goethe, Schiller, Lessing, and other German writers, and the

20. Theodor Körner (1791–1813) was a popular playwright and poet in Germany who died fighting the French during Napoleon's invasion of Germany.

21. From William G. Bek, *The German Settlement Society of Philadelphia,* trans. Elmer Danuser, ed. Dorothy Heckmann Shrader (1984), 250.

22. Bek, *German Settlement Society* (1907), 138.

library of thirteen hundred volumes included over seven hundred German publications.

In 1847 a *Theaterverein,* or theater club, called *Erholung* was officially organized in Hermann, with a building of its own where musical programs and dances as well as theatrical performances were held. On February 29, 1852, Eduard Muehl and others founded a Hermann chapter of the *Verein freier Männer,* the Society of Free Men, dedicated to "striving for freedom, truth, and justice in religion as well as in politics." At the March 28 meeting of the *Verein freier Männer,* Muehl was asked to compose a suitable song with which meetings could begin and end. He soon obliged with a six-stanza composition dedicated to "a freer life / Free from fanatic beliefs / To a higher striving / On the path of humanity."[23]

Although Hermann had its share of political activists, radicals, rationalists, and free-thinkers, the latter opposed to any imposition of authoritarian religious dogma, it also had solid segments of the population that adhered to various traditional religious tenets and followed precepts of traditional churches. Both Catholic and Protestant churches flourished.

Parallel to the cultural, political, and social activities in Hermann—the dances, concerts, plays, lectures, and events sponsored by the various organizations—continuing efforts to further agricultural and economic progress continued. Construction of the long-awaited Pacific Railroad reached Hermann in 1854, and a market house was built in 1856. Market stalls were sold to the highest bidders, regulations were modeled after those of the St. Louis market house, and a market master was employed to enforce regulations and oversee the operation of the market. Although residents must have known by midcentury that Hermann would not overtake St. Louis in importance, they devoted much care to maintaining a favorable environment in their "Little Germany," as the town came to be known throughout the state. As log and frame structures built by the early colonists began to give way to the sturdy and distinctive buildings of brick made from local clay, dwellings and businesses continued to be placed at the front edge of the lot adjacent to the sidewalk to allow for large gardens and grape arbors in the back. Public buildings devoted to education, the arts, and commerce reflected memories of the substantial structures in the homeland the settlers had left behind. Not only in spirit, but also in appearance, Hermann strove to be "German in every particular," as its founders had planned.

Even the best-laid plans, however, could not spare the ambitious and prosperous little city from the epidemics that plagued St. Louis and other Missouri communities at midcentury. Cholera was a grim counterpoint to progress. It struck in 1849, the year the German School was established, and in

23. Ibid., 164, 165-66. The constitution and minutes of the *Verein freier Männer* are in the Hermann, Missouri, Papers at the Missouri Historical Society in St. Louis. There were seventy-six signatories to the constitution.

Hermannhof Winery

The former Brewery (see page 46) is now the home of Hermannhof Winery. The growth pattern of the building can be seen from the evidence of an addition on the far end and the small wood el. The standing seam roof became widespread in Hermann after the 1870s, and even the introduction of asbestos tiles about 1900 did not result in the replacement of the metal roofs, which continued to be installed well into the twentieth century.

Jacob Krobel started the brewery before 1856. (Photograph by Oliver Schuchard, 1991.)

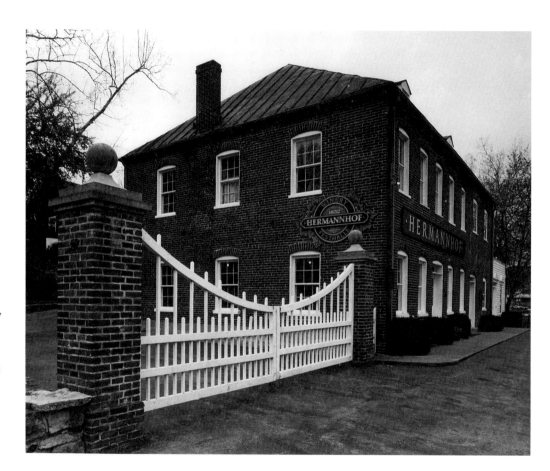

1854, brought by the railroad workers. During both epidemics, the courthouse had to be used as a hospital. Eduard Muehl, the fiery radical and newspaper editor who had promoted Hermann so enthusiastically, died of cholera on July 7, 1854. His wife, Pauline Strehly, made an entry in her husband's journal to record his death: "July 7, 1854 at 1:30 in the afternoon my husband died. . . . About 5 the same day our little daughter Rosa died and was laid to rest with her papa on the 8th."[24]

After Muehl's death, his brother-in-law Carl Strehly sold the *Hermanner Wochenblatt* to Jacob Graf, who renamed it the *Hermanner Volksblatt*. The newspaper remained in the Graf family for many years until it ceased publication in 1928. The English-language *Advertiser Courier* was established by the Graf family in 1873 and continued the tradition of service to the Hermann community to which its German sister publication was dedicated.

On the occasion of the birth of Siegmar, the third of his eight children, on November 8, 1846, Muehl had noted in his journal that all his children had been born in the morning: "I would hope it is a sign that they will take active part in the spiritual morning light which will break powerfully over our times."[25] By the time of his death, however, he had sensed the impending conflict between the North and the South that would result in the destruction and tragedy of the Civil War. Missouri was soon to become a battleground between its citizens of opposing views.

A note placed in Muehl's journal (reportedly his dying words) epitomizes his beliefs.

> My whole life was dedicated to freedom. I die as a free man. I have endeavored to do my duty; do yours. And may you see freedom bloom more completely and more wonderfully than I have seen it. That is my farewell to all free men, to all progressive organizations of all kinds and all friends of freedom. Tell them this![26]

Strongly opposed to slavery, Hermann supported the Union as war approached, and as was the case in other German areas of the state, suffered threats against its people and businesses by Southern sympathizers. After the Civil War began, the strong abolitionist views (and sometimes critical statements about those directing the war) of Hermann newspaper editor Jacob Graf brought him into disfavor with the Missouri authorities. In 1863 he was arrested and taken to Jefferson

24. Muehl, "Eduard Mühl," 35.

25. Adolf Falbisaner, "Eduard Mühl, A German-American Champion of Freedom and Human Rights," 57. Arpy E. Hacker translated from the original German version, *Eduard Mühl, Ein Deutsch-*

Amerikanischer Kämpe für Freiheit und Menschenrechte; both versions are in the State Historical Society of Missouri.

26. Falbisaner, *"Eduard Mühl,"* trans. Hacker, 120.

City, where he was warned to restrain his abolitionist sentiments and his criticism of the military in his editorials in the *Hermanner Volksblatt.*

The town of Hermann was relatively isolated from the war, but in 1864, as General Sterling Price, in a last effort to secure Missouri for the Confederacy, marched westward along the Old State Road, he sent a vanguard under the leadership of General John Sappington Marmaduke along the Missouri River. Residents of Hermann had been warned of the approach of the troops, and as the Confederates reached the edge of town they were met by cannon shots, first from one hill and then another. Since he thought all the young men of Hermann were in the Union Army, Marmaduke believed he had been engaged by enemy troops and sent out a scouting party. They found only one cannon. It had been dragged from one hill to another by the older men of the town and others no longer in active service, some of whom had received military training in the various German states from which they had come. As soon as the cannon shots had been fired, they had left with the women and children and the town was deserted. The Confederates threw the cannon into the river before proceeding toward Jefferson City on Price's futile mission, which ended with the battle of Westport, October 23, 1864, and his subsequent retreat along the Kansas-Missouri line to Arkansas. Residents of Hermann later fished the cannon from the river and put it on the courthouse lawn.

Although resentment of German support for the Union cause was to linger in Missouri for many decades, the end of the Civil War brought the beginning of the golden age of Hermann's economic growth with the rebuilding and further development of the grape and wine industries. The Stone Hill Wine Company, developed from a winery started in 1847 by Michael Poeschel on a hill that marked the southern boundary of Hermann, became the third-largest winery in the world, the second in the nation. By 1904, Missouri shipped a twelfth of the wine placed on the market by all the states, 3,068,780 gallons. Of this, the various wineries of Gasconade County furnished over 90 percent, or 2,971,576 gallons.[27] In addition to its prize-winning wines, which won gold medals in at least eight World's Fairs, Stone Hill operated a distillery in Kentucky and a large bottling plant with offices in St. Louis. Under the management of George Stark, the company achieved an enormous success.

In 1886, Hermann marked its fiftieth anniversary with an exuberant three-day celebration to which "all friends of German spirit and German civilization" were invited. The historian William Bek, describing Hermann's Sunday activities at the turn of the century, evoked a cultural and social environment markedly more European than "American." The people of Hermann celebrated, as Muehl had noted earlier, in their own way, not according to the ways of their English neighbors:

27. Bek, *German Settlement Society* (1984), 237.

The people of Hermann believe in a joyful Sabbath. It is their fete day. Public opinion outside of their community deters them not a whit. The *Maifest* of the public school, when young and old gather at the pretty park, always falls on Sunday. The gala-day of the Gasconade County Fair is Sunday. Lodges and societies hold their festivities and dances on Sunday. The *Schützenfest* and baseball games fall on this day. Every summer from six to eight Sunday railroad and boat excursions bring throngs of pleasure seekers from St. Louis and other places to "Little Germany." . . . Music and song and wine lend their share towards a pleasant day, whose evening comes only too soon.[28]

The tension between Anglo-Americans and European immigrants caused by the persistence of the foreign language, political activism by some immigrant organizations, and differing social customs was intensified in nineteenth-century America by what the historian Carl Wittke has called the "Continental versus the American Sabbath." The struggle to enforce Sunday closings of theaters and beer gardens in Missouri began before the Civil War and continued long afterward. Yet for many residents of Hermann, Sunday activities were not too different from those of their American neighbors—with the exception that the language of the church was German. Activities sponsored by the churches were an important part of community life and served to perpetuate the use of German for several generations.

Many talented and productive residents of Hermann contributed to the area's economic and cultural life during the period of its greatest prosperity. They continued to struggle to preserve their town when both its prosperity and major aspects of its cultural life came to an end with World War I and Prohibition, as Hermann and other wine-producing German communities were forced to give up their livelihood and encouraged to subdue their "Germanness." In some areas of Missouri, a vote for Prohibition in the years prior to actual passage of the Eighteenth Amendment was considered a vote against the Kaiser,[29] and after America's entry into the war, the Missouri Council of Defense advocated strong measures to eliminate the use of the German language in churches, schools, and businesses. It was not a happy time for Missouri's Little Germany or the other predominantly German towns along the "Missouri Rhineland" and throughout the state. However, with an energy and resilience typical of Hermann, the massive cellars of the Stone Hill Winery were adapted for commercial mushroom production, and fruit orchards replaced vineyards. Charles van Ravenswaay reported in the late 1930s that in the twenty cellars of the Stone Hill Winery, some of them two hundred feet long and a hun-

28. Ibid., 246.

29. An advertisement in the *Springfield Daily Leader* of November 4, 1918, exhorted readers that "a dry vote is a vote against the Kaiser . . . a vote for Democracy."

dred feet wide, an estimated sixty-five tons of mushrooms were grown annually.[30]

Although the area inevitably fell into a period of cultural and economic dormancy as the Great Depression settled over the nation, its population, which had hovered around 1,500 throughout the nineteenth century, rose to 1,700 by 1920 and 2,063 by 1930.

In the 1930s, van Ravenswaay found Hermann "freshly scrubbed, dusted, and swept . . . the wide market place, and prim red-brick houses along the sidewalks (sometimes paved with flagstones), remind one of Rhine Valley towns."[31] Although reminders of the homeland existed and were often mentioned, there were many reasons why Hermann never became a replication of a German village. As its founders came from all parts of Germany, some after a number of years in America, they brought with them widely varied building traditions. Early settlers were largely limited to the materials readily available to them—limestone, brick made in the colony, and the abundant oak and walnut in the forests. Development of the town progressed in stages, as its residents prospered. Some of the seventy young men from Hermann who joined the Gold Rush to California earned enough in the venture to build homes in Hermann and its environs upon their return. Others achieved wealth later in the century, after exposure to architectural styles popular in neighboring American communities and nearby St. Louis. In her study of Hermann residences and other buildings, Anna Hesse has noted that a change in house types and placement of buildings occurred between 1860 and 1870, either because of increased prosperity or because the second generation of Hermann's residents were more influenced by American building traditions.[32]

It is often in the details of the building, rather than in the buildings themselves, that differing German traditions are reflected. The individuality of the artisans was expressed in the brickwork on cornices and door and window frames and in other creative touches. Anna Hesse has found no two cornices alike in the buildings that make up the twenty-two block Historic District of Hermann.[33] The visitor is often surprised by such details as the arched gateway leading to the garden overlooking the town and the carvings of the *Lippische Rose,* the symbol of Lippe-Detmold, that grace the archway, doorway, and windows in the little *Schloss* Carl Schroeder built

30. Charles van Ravenswaay, *Missouri: The WPA Guide to the "Show Me" State,* 394. Originally published by Duell, Sloan, and Pearce in 1941 under the title *Missouri: A Guide to the "Show Me" State.*

31. Ibid., 393.

32. Anna Hesse, Presentation at the Annual Conference of the Society for German-American Studies at the University of Missouri–Columbia, April 19, 1980 (tape recording on deposit in the Adolf E. and Rebecca B. Schroeder collection at the Western Historical Manuscripts Collection, Columbia, Mo.).

33. Ibid.

for his family on East Hill about 1860. Van Ravenswaay noted the German casement windows, the wide doorways to accommodate wine casks, the placement of the gabled ends of the houses to the streets, and other evidences of German influences in his 1930s research for *Missouri: A Guide to the Show-Me State.* In his in-depth research for the Archives of American Art Project, which began in 1961, and his continuing work, which culminated in *The Arts and Architecture of German Settlements in Missouri,* he discovered many reminders of the German artisans who were drawn to Hermann in the mid- and later nineteenth century, both in the form and ornamentation of buildings as well as in interior details and the handcrafted furniture and other objects that are still in use.[34]

Today Hermann retains a European atmosphere decidedly in contrast to other small Missouri towns. Its architectural integrity and ornamented buildings are not only a testimonial to the craft and skills of its early settlers but also to the commitment of present-day residents to preservation efforts. Beginning in the 1950s, the members of the Brush and Palette Club undertook a variety of projects to obtain funds to restore the historic structures. In 1952 the annual *Maifest* was revived after a thirty-year hiatus. Opened to visitors, the festival became an

immediate tourist attraction. Annual historical pageants, written by Anna Hesse, were produced by the Brush and Palette Club from 1952 through 1964. In 1968, plans were developed to place the old part of the city on the National Register of Historic Places. Hesse searched through records and interviewed longtime residents to prepare a detailed descriptive list of the early buildings, *Centenarians of Brick, Wood, and Stone,* a work that was largely responsible for the successful effort to have Hermann's Historic District placed on the National Register in 1972. Two of the early historic buildings in Hermann, the Pommer-Gentner and Strehly houses, purchased by the Brush and Palette Club in 1952 and 1963, were given to the State of Missouri in 1978 and opened to the public in the spring of 1979 as a state historic site, *Deutschheim,* by the Department of Natural Resources. With a present-day population of about three thousand, Hermann continues to celebrate its unique heritage with a variety of spring, summer, and fall festivals, including a *Volksmarsch,* which brings participants from Germany. For the annual *Maifest* and *Oktoberfest,* Amtrak trains make a special stop at the city on the run from St. Louis to Kansas City, a reminder of Hermann's early days when St. Louisans spent Sundays in Little Germany on the Missouri.

Although the wine industry is thriving again, Hermann's economic stability today is largely due to the revitalization of the cultural and social traditions that the founders of the German Settlement Society of Philadelphia hoped to perpetuate on the Missouri frontier. The language they sought to preserve

34. Charles van Ravenswaay, *The Arts and Architecture of German Settlements in Missouri: A Survey of a Vanishing Culture,* ix-x, describes the Archives of American Art Project; he discusses Hermann on pages 46-57 and elsewhere throughout the book.

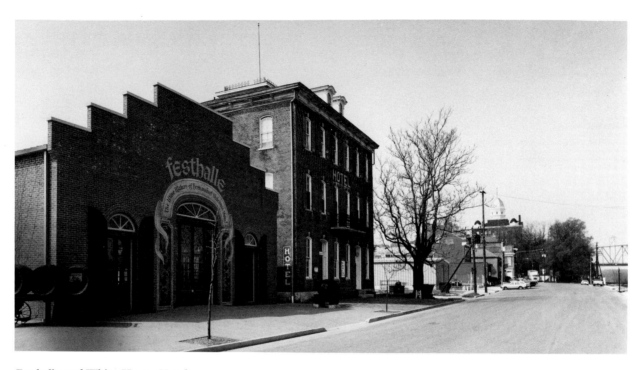

Festhalle and White House Hotel

The Festhalle on Wharf Street has a new facade in the North German style, close to the spirit of the German river towns. In the much older White House Hotel, Anglo-American influences on the German Vernacular can be seen in the inclusion of white decorative keystones on its front windows and doors, the arched dormers, and the widow's walk atop the building. This was at one time the most elegant hotel in Hermann. It faces the river and railroad, and welcomed many well-known guests.

In the background, the courthouse rises above the town. (Photograph by Oliver Schuchard, 1991.)

is largely lost, but the cultural identity of the descendants of early settlers has maintained itself. Curiously, this German American city on the Missouri is in many ways an enigma to the modern-day German visitors who come to participate in the festivals and other events. A German television crew expressed bafflement that "even in present day Hermann the representatives of the Historical Society attempt emphatically to defend the German character of the city against the influences of the twentieth century."[35] If a sense of cultural identity represents ethnicity in America today, then Hermann has succeeded in achieving the aims of its founders.

Anna Hesse has pointed out that Hermann is "in no sense a museum" but instead a city in which life has been continuous, with the old represented by surviving cultural traditions and carefully maintained historic buildings, shading into the new. "There is youth and vitality" as well as the opportunity to "turn back the pages of history."[36] Perhaps it is in this duality that Hermann's importance in American cultural history lies. Edward Kemper's photographs, preserved by his daughter, turn back pages of history for us and at the same time reflect the vigor that sustains the community today.

35. Flyer, "A Brief Description of the German TV Film of Hermann, Missouri," n.d. The 1978 televised program on Hermann, "German Past in America," is said to have brought more than two hundred visitors from Germany to Hermann in 1979. A sister-city relation-ship was established with the Hessian city of Arolsen in 1986, and an enthusiastic exchange of student and adult groups has developed.

36. Anna Hesse, undated note to Adolf E. Schroeder.

Edward Kemper as Photographer

OLIVER A. SCHUCHARD

When Edward Kemper purchased his first camera in 1895, a Kodak with Bausch and Lomb lens and glass plates, he joined the ranks of amateur and professional photographers across the country who were documenting life in America at the end of the nineteenth century. Kemper concentrated almost exclusively on recording life events and scenes of family, neighbors, relatives, friends, and church, but these encompassed the world of his German American community. Scenes of economic prosperity, community growth, technological progress, and civic and national pride were subjects for his camera. Subject matter alone, however, does not categorize him as unique among his peers. Lesser photographers, both amateur and professional, as well as accomplished itinerant and studio practitioners, regularly captured similar subjects. The relevance and strength of Kemper's photographs arise from a variety of circumstances that influenced his community and his work.

In a half century Hermann had grown from a frontier river set-tlement of log houses, mud streets, and dire hardship to a prosperous community. Linked to St. Louis and the East as well as to the West by railroad and steamboat, Hermann had convenient access to established and new markets for manufactured and agricultural products. Yet it had the advantage of being able to retain its distinct ethnic char-acter largely because of geographic factors that ensured a relative isolation during its early years. Prosperity and subsequent growth fostered economic independence, and the steadfast resolve of its founders to preserve their German heritage, language, and traditions distinguished the town from other communities in the heartland. While it is probable that itinerant photographers worked in Hermann from time to time, it is unlikely that their photographs conveyed the directness and insight inherent in Kemper's work. Such photogra-phers, while facile in the craft of the medium, produced documen-tary pictures and portraits that were typically most meaningful to the subjects themselves. Their work resulted in apt rendering of detail

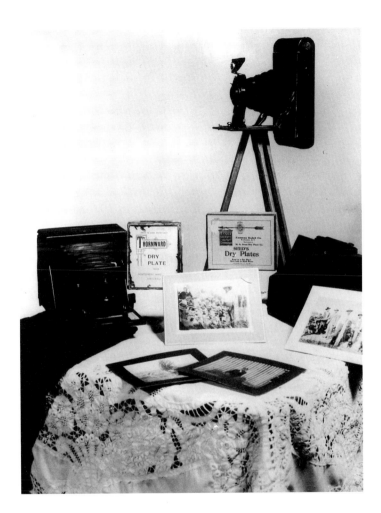

The Photographer's Tools

This view of Edward Kemper's photographic equipment and sample photographs was made in 1985 by Hermann photographer John Wilding. (Print by Oliver Schuchard.)

and good likeness but was often lacking in empathy, perception, and understanding of cultural-social cause and effect.

In any visual medium, but especially in photography, elements of craft and design provide only a visual framework for the presentation of one's observations and reaction to life experience. The visual character of Edward Kemper's photographs and their value to the contemporary viewer go well beyond competent technique and logically organized, occasionally naive compositions. His photographs are pertinent and sensitively executed documents specific to the circumstance of community, family, and friends. They are decidedly richer in content because Kemper was able to convey that which, in his mind's eye, comprised the essence of Hermann. He pursued his craft from an informed life view. As the son of immigrant pioneer parents, a dedicated husband and father, successful businessman, and prominent member of the community, he was personally involved in all aspects of life in Hermann. He was both a citizen of the community and a benefactor of its substantial prosperity. His photographs draw on his roots in Hermann and therefore embody the inner character of the town in ways an outside observer cannot achieve. Therein lies their uniqueness, beauty, and evocative power.

In the broadest sense, the Kemper collection of negatives and prints represents a wonderfully diverse interpretation of a Missouri River valley town in the closing years of the nineteenth century and the early years of the twentieth. Certainly this is a valid reason in itself to study, cherish, and preserve the collection. But the real impact of the photographs lies in the historical-cultural context of the time and place and the sensitivity of the photographer to the character, circumstance, and events that made Hermann unique.

Edward J. Kemper was a documentary photographer of considerable and defined accomplishment. He responded visually to events and characters in Hermann at a level of eloquence that is underscored by his visual sensibility as well as by his apparent realization of his place in time and Hermann's role in the golden age of German American culture in Missouri.

I

Building Hermann

A BALANCE OF MANUFACTURING AND AGRICULTURE

The more than 11,000 acres purchased on the south bank of the Missouri River in 1837 by George Bayer for the German Settlement Society included river access both to the Missouri and the Gasconade rivers, incorporated much of two sizable local streams, and included flat bottom land as well as hilly tree-covered terrain. A site partially cleared by three Anglo-American families became the location for the new town of Hermann when the first settlers arrived in December, 1837. By 1839 a brick kiln had been established, making possible the construction of the first of the permanent buildings which still distinguish the town. A variety of businesses developed, ranging from the building trades— bricks, stone masonry, a steam lumber mill, lime production for plaster and mortar—through cigar manufacturing, beer brewing, and distilling. There were furniture makers, the usual drygoods and grocery stores, bakeries, blacksmiths, wagon makers, a tannery, and all the other support services needed in a community supplying a growing agricultural region.[1]

1. Erin M. Renn, "A Golden Age of German-American Culture: Hermann, Missouri 1895-1920." Brochure for exhibit, 1992.

At the turn of the twentieth century, the appearance of Hermann, its businesses, and town residences was in many ways strongly reminiscent of the nineteenth-century villages in Germany from which its early settlers came, with many of the brick buildings built flush with the sidewalk, leaving more room for family gardens in the back. Hermann's historic district includes about one hundred houses built between 1838 and 1860. There are four stone houses, but most are built of locally produced brick. These buildings, whether large or small, demonstrate the craft and skills of local artisans. The creativity of the builders can be seen in the elegant or fanciful brickwork above windows and at cornices and in decorative metal work. Even today a few of the original wrought-iron balconies are still in evidence. The small gardens are tucked in the rear, where *Hausfrauen* could often be seen taking care of their well-manicured lawns and vegetable gardens intermingled with flowers. The placid streets, in spite of the hills, stretch in well-ordered regularity according to the

plans of Hermann's founding fathers. Hermann's settlers did not conquer nature so much as make peace with it.

The surrounding area of Gasconade County, where early settlers established farms and vineyards, has a rich and varied physiography. It is the valley-cut Ozark plateau, worn down from ancient mountain heights, the eroded bluffs along waterways, the bluegrass pastures of the hillsides. At one time called the State of Gasconade, its boundaries included a large part of Missouri, comprising the present area of eleven counties and parts of twelve others. By 1825, the boundaries of the county included only parts of present Crawford and Maries Counties and all of Osage County. In 1841 Osage County was established, making Gasconade still smaller. Today it is fifteen miles wide and thirty-five miles long, drained by Frene Creek, Little Berger, First, Second, and Third Creeks, and the beautiful Gasconade and Bourbeuse Rivers.

"On this scenic route through a partially timbered upland," Charles van Ravenswaay wrote in the 1930s, the traveler "slips with breath-taking suddenness into the picture-book valley of Hermann."[2]

2. Charles van Ravenswaay, *Missouri: The WPA Guide to the "Show Me" State,* 393.

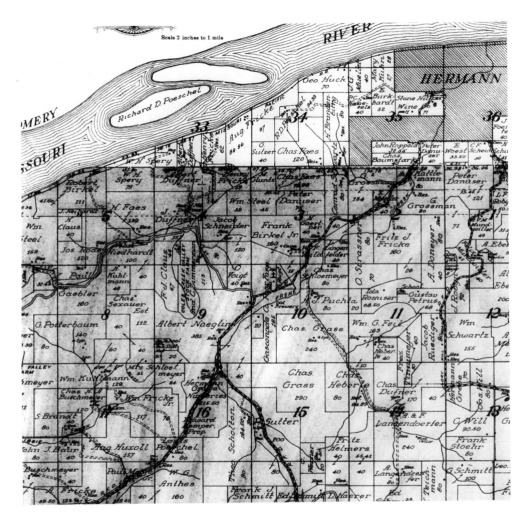

Map of Northern Gasconade County, Standard Atlas, 1913

(Courtesy State Historical Society of Missouri, Columbia).

Market Street in Winter

When the German Settlement Society's colony was laid out on paper in 1837, planners wanted one street to be more impressive than its counterpart in the city of Philadelphia: Market Street was to be ten feet wider than Philadelphia's Market Street, to accommodate the thriving business that Hermann's founders believed would develop to rival St. Louis. A market house, built in the middle of the street in the 1850s, had been a focus of the town's life for decades. By the 1890s Hermann had become a weekend destination for train excursions and was popular with St. Louis day-trippers. City leaders may well have had tourism in mind when they decided to redesign Market Street, which runs north-south from the Missouri River, and turn it into an attraction for townspeople and visitors alike.

The traffic, which had run down the middle of the street, was rerouted into one-way lanes along either edge, creating a wide grassy promenade in the middle of the former roadway for three blocks. Trees were planted down both sides in a double row to shade the divided roadway and create inviting strolling areas in the new park itself. The result was to be a wooded allée like that adorning many German cities. The young allée is shown in this snow scene with boys sledding in front of the firehouse and city hall, built in 1906.

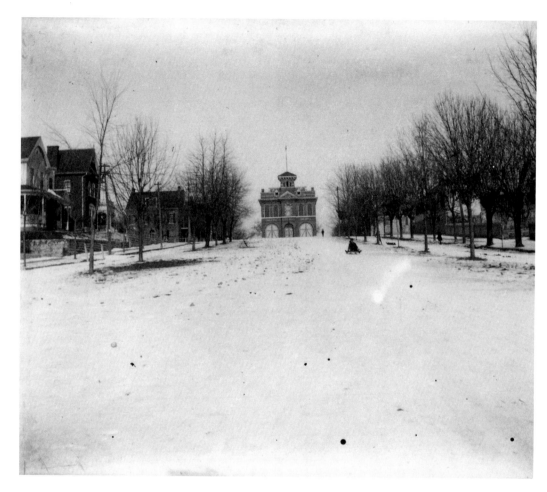

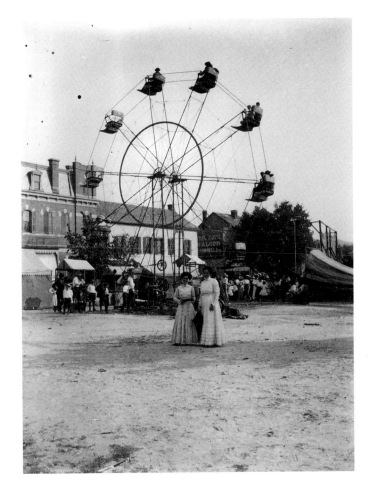

Ferris Wheel on Market Street

At the turn of the century, Market Street epitomized the small-town main street, the heart and soul of the community, the center for business, civic, and social activities. It differed, however, from neighboring Anglo-American towns in the character of the buildings lining the street and the sound of spoken German, reflecting the community's unique character and heritage. The Market Street median once extended from First to Sixth Street, and when a small traveling carnival came to town, it was set up between Fourth and Fifth Streets.

The Ferris Wheel, which had been invented in 1893 by George Washington Gale Ferris for the World's Columbian Exposition in Chicago, had been designed as something to rival the Eiffel Tower at the 1889 Paris Exposition. It carried 60 passengers in 36 enclosed cages—2,160 people per ride. Smaller versions that could be hauled to fairs and celebrations throughout the United States were soon available for such towns as Hermann.

The buildings in the background, to the right, the Kimmel Hotel and Saloon (later the Nagel Saloon), are still in place. The storefront with the mansard roof is one of seven buildings in Hermann with mansards dating from the late nineteenth century. August Begemann built two, a store at Front and Schiller for his son Armin, and this one at Fourth and Market for his son Louis.

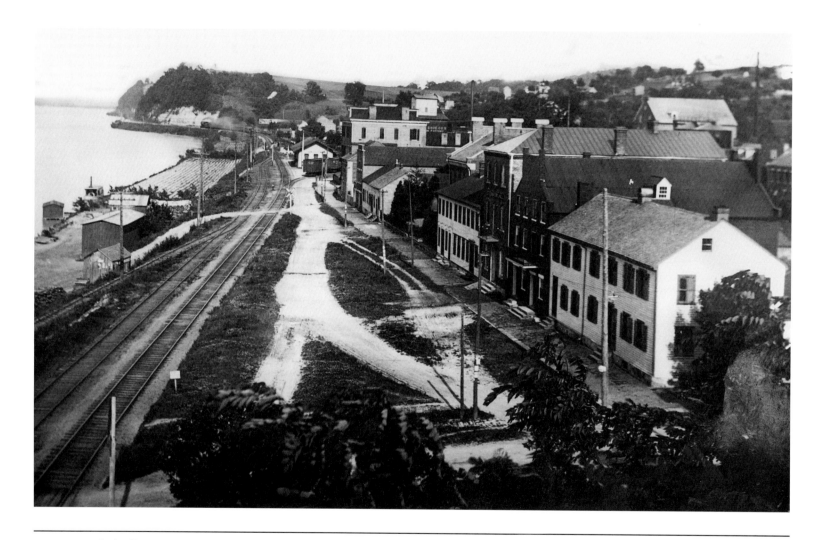

Wharf Street

Perhaps the most reproduced of Edward Kemper's photographs, this view of Wharf Street about 1900 shows a variety of businesses and the handsome Charles D. Eitzen residence facing the busy riverfront. The block between Schiller and Gutenberg Streets was the business center in early Hermann. Most of the buildings shown in the photograph are still standing: facing the river at the far end of the street is the White House Hotel, a three-story building with a widow's walk, built about 1871. The hotel at one time offered the ultimate comfort in accommodations, and many dignitaries stayed there. Next to the hotel are several smaller buildings, one a cigar factory. The elegant Eitzen House, circa 1855, a two-and-a-half-story structure, is set back from the street, unlike the other buildings. The long white building next to it was the Augustus and Louise Leimer Hotel, circa 1839, Hermann's first hotel. It was called into service as a hospital in April 1845, when the steamboat *Big Hatchie* exploded, badly injuring many travelers, and again in November 1855, when the Gasconade River bridge collapsed beneath the weight of the first passenger train bound from St. Louis to Jefferson City.

The taller, three-story building next to the Leimer Hotel was the Widersprecher Store, circa 1839, in which Charles D. Eitzen served as clerk upon his arrival in Hermann. Eitzen bought the store after three years and established a lucrative business with the Massey Iron Works near St. James in Phelps County. From 1840 to 1860 iron blooms, ready for further working, were hauled the sixty-five miles from Meramec Spring to Hermann by ox team to be shipped by boat (later by rail) to St. Louis. The wagons always returned to the Iron Works loaded with dry goods and provisions purchased in Hermann for the miners and their families. Eitzen also traded in shortleaf pine lumber from southern Missouri for shipment to St. Louis. He often had as much as two hundred thousand feet of lumber piled along Wharf Street.

Next to the brick Pacific Hotel with stepped gables, the white building in the foreground was the Jumbo Saloon, run by Albert Schubert.

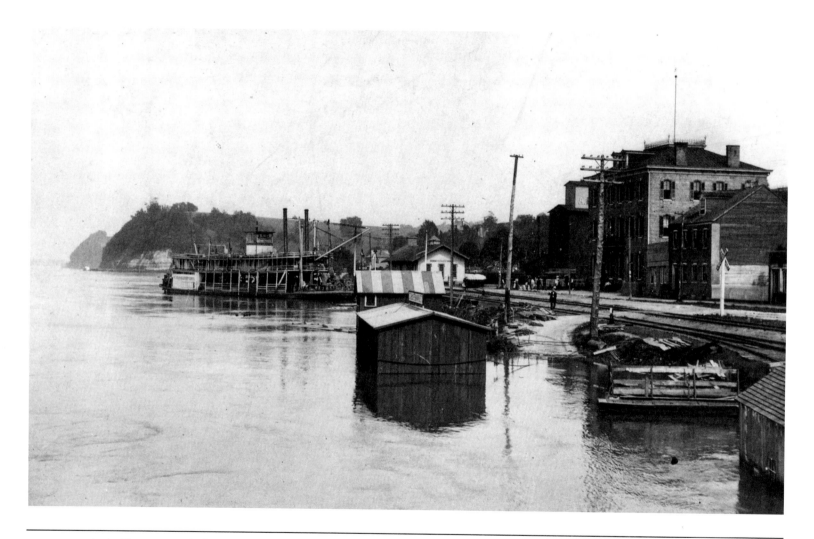

The Riverfront

Hermann can boast its share of riverboat captains: Captain Ed Heckmann, one of eight brothers who were all rivermen like their father, piloted steamboats on the Missouri and other waterways. Among others were Henry German, Frank Blaske, Harry Burger, and later, Captain Kermit Baecker.

By 1849 about fifty steamboats regularly made trips up the Missouri from St. Louis. The riverfront was also the busy site of boat-building activities. Here boats were designed and built, most of them under the direction of Johannes Bohlken, a ship carpenter and designer from the Grand Duchy of Oldenburg, Germany. White oak was the only wood that would last in the water, and suitable joists without knots, ten to fourteen feet long, could be obtained in the area.

On the distant bluff in the background, Civil War veterans flew the U.S. flag for many years in memory of Captain Charles Manwaring, brother-in-law and partner of George Husmann, who was killed in the spring of 1864 by a party of Confederates while he was visiting his family in Hermann.

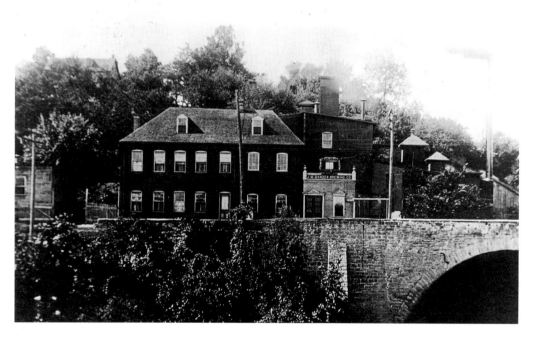

Brewery

The J. D. Danzer Brewing Company was once flanked by one of Hermann's three stone-arched bridges, all built by Magnus Will, a stone-mason from Germany. Jacob Krobel started a brewery on Front Street and Frene Creek before 1856. By 1877 Hugo Kropp, then the owner, was producing 454 barrels of beer annually; by 1888 production had grown to 4,000 barrels. At the time this photograph was made, the building was occupied by the J. W. Danzer Brewing Company. In 1895, the brewery was one of Hermann's largest employers. East Hill is shown in the background.

The Brewery complex, with its buildings and storage cellars, is now Hermannhof Winery (see photograph by Oliver Schuchard on page 26).

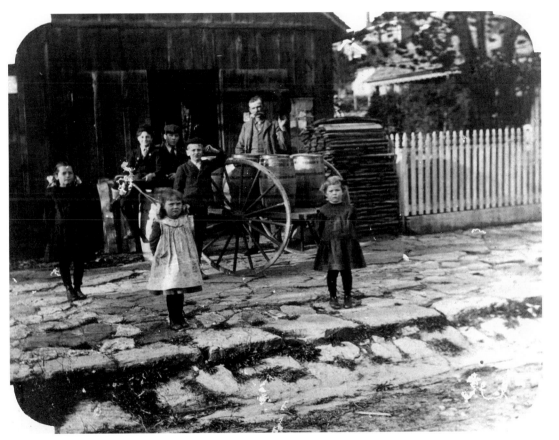

Henry Bock Cooperage

Coopers were once an essential part of Hermann's economy, meeting a wide array of needs. Note the small, completed barrels on the gig, the double-heart picket fence, and the flagstone sidewalk and gutter. Henry Bock made barrels for the wineries, and his cooperage shop on West Third Street was always of interest to the children.

Lime Burners

An early industrial scene at Fourth and Market Streets shows lime burners at work and conveys a sense of the heat, dust, and hard labor involved. Henry Sohns burned lime for mortar and plaster. He and his helper are seen stoking the lime kiln. The Sohns family owned several concerns, including a pottery, the lime kiln, and later a winery. Henry Sohns was one of Kemper's closest friends.

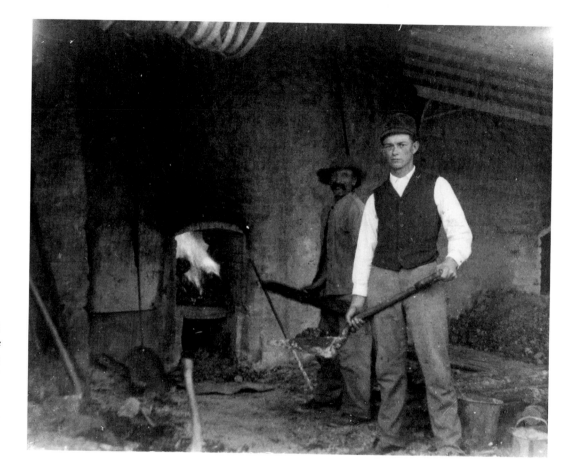

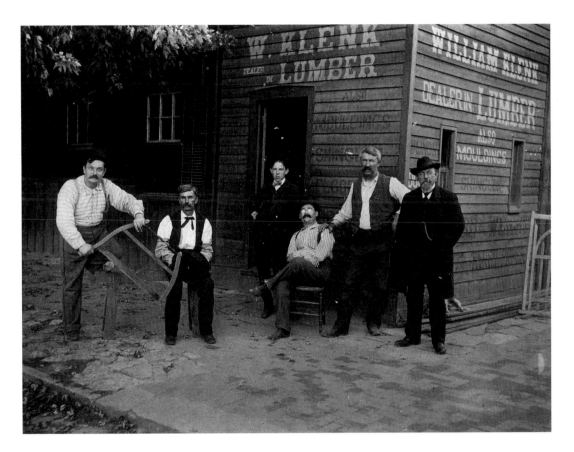

Klenk Lumber Company

A gathering at the Klenk Lumber Company at Fourth and Market streets: Julius Moebus, holding a *Bocksäge,* or frame saw, Frank Rebsamen, George Klenk, Louis Begemann, and William Klenk are with an unidentified visitor. The sidewalk is paved partly with brick, partly with limestone. The strong shade cast by a maple tree, the brick and flagstone walks, and the heavy wool suits on two of the men indicate a time long gone by in Hermann. Today the site is edged by the four-lane Highway 19.

Leather for the Shoe Factory

One of Kemper's industrial photographs shows the first load of leather for Peters Shoe Company, which arrived packed in barrels in 1902. The heavily loaded wagon and the hard-working horses form a striking image of a time when progress had its costs. The shoe factory is seen in the background, at the corner of Fourth and Gutenberg. Because of heavy traffic to the factory, this area was paved with bricks long before other streets in town.

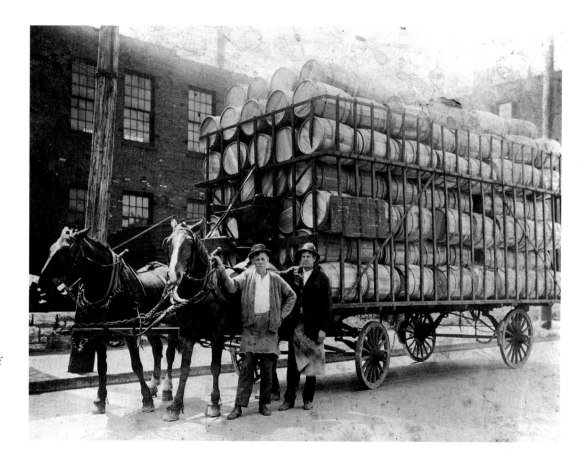

The Gasconade County Courthouse

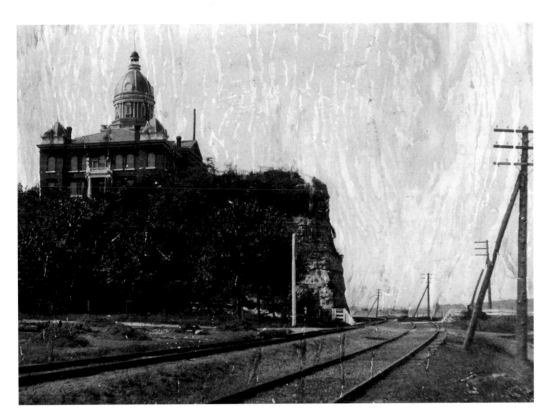

The county's first courthouse was built on this same high bluff above the Missouri River in 1841, a twenty-by-twenty-four-foot, two-story, brick neoclassical building costing $303.00. In 1896 Charles D. Eitzen, a Hermann merchant, left $50,000 in his will for a new courthouse, a gesture of public generosity rarely equaled. The new building was completed in 1898. The interior of this courthouse boasts beautiful iron staircases and mosaics in the floor. A vine-yard was planted on the west side of the grounds. Between the Missouri River and the court-house are the tracks of the Missouri Pacific Railroad.

In 1905 a fire caused by faulty wiring broke out in the dome of the new courthouse, but the quick work of Hermann Fire Company No. 1 saved the build-ing. The rebuilt dome lacked the cupola in the original design shown in this and other early photographs.

Flood in Hermann

Hermann suffered severe flooding in 1903, and Kemper captured its effect in a series of dramatic townscapes. Floodwaters backed into the town, swamping the Frene Creek valley.

The half-timbered stone house, its reflection caught in the water's smooth surface, is now gone, as are its neighbors. St. George Catholic Church, on the hill to the right, was much altered and enlarged a few years later, and the stone arched bridge has been replaced.

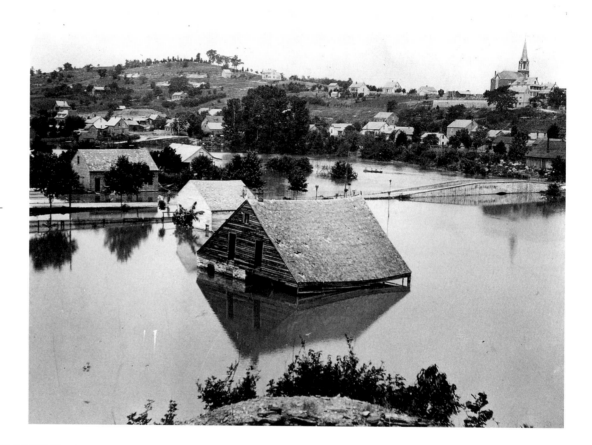

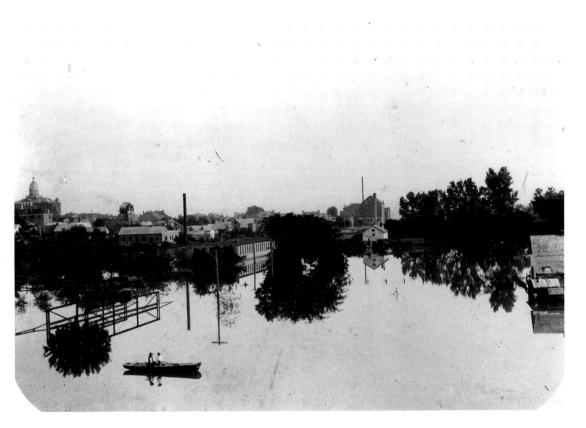

Flood on Gutenberg

Again Kemper has captured reflections as an essential part of his composition in this flood picture. The shoe factory in the center and the tall steam-powered 1861 Star Mill identify this view as being of Gutenberg Street. The courthouse, with its original dome, is at the far left.

View of Hermann from the West, Showing the Missouri River

A view of Hermann looks east from what used to be called Lone Tree Hill at a time when there were many in-town vineyards and fruit orchards intermingled with the houses, showing St. Paul's Evangelical Church and the courthouse with its rebuilt dome. Directly behind the church and courthouse is the wide expanse of the Missouri River, dotted with islands, before it was channeled by the Corps of Engineers. The mouth of the Loutre River and Loutre Island can be seen at the upper center.

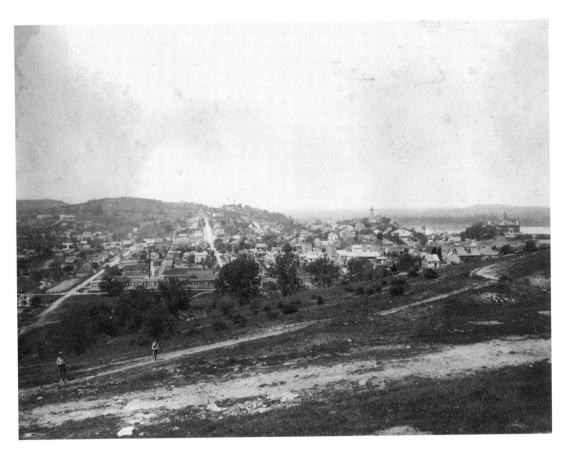

View of Hermann Looking West from East Hill

This panorama of Hermann, looking west from East Hill about 1908, shows Hermann's houses, gardens, orchards, and vineyards. The clock tower of the German School rises in left center, and the newly built St. George Catholic Church and St. Paul's Evangelical Church (now the United Church of Christ), face each other from their respective ridges in the middle ground. The Gasconade County Courthouse sits on the south bluffs of the Missouri River. Russel Gerlach has noted that the churches and the courthouse are equally prominent in Hermann.

Making Soap

Large iron kettles were used for making soap, which is drying in the background. Typical double-heart picket fencing and a fruit tree can be seen in this backyard scene in Hermann with an unidentified resident posing for Kemper.

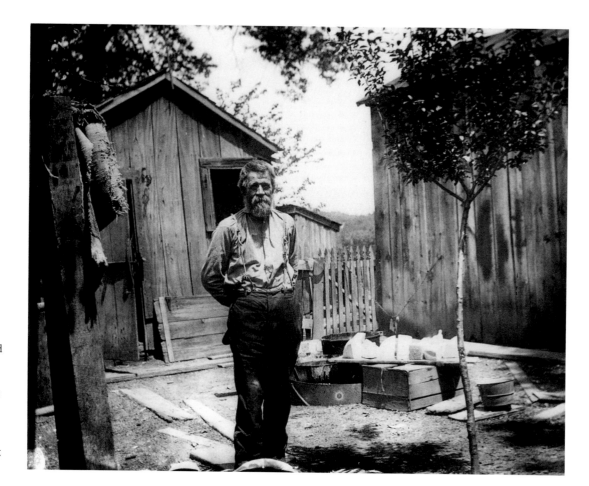

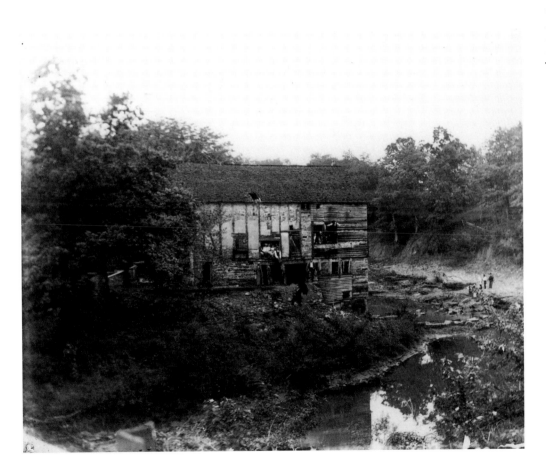

Kemper Mill

The gristmill on Big Berger Creek was originally known as Widow Tugel's Mill. Edward's brother John, trained as a miller in Germany, worked there when he first came to Hermann and later married the owner. Built over a solid limestone foundation with huge timbers, the mill shows the half-timbered construction traditionally used in Germany. The heavily framed superstructure shows weatherboarding on the right above the creek. The space between the framing of the outer walls was filled with stones and rubble and then plastered. The roof was covered with split shingles. In spite of the relatively large rectangular size of the building (over forty feet), few horizontal or diagonal braces are evident between the vertical timbers.

Many half-timbered water-powered mills once dotted the countryside settled by German immigrants. Kemper Mill had been abandoned by 1901, when a church group went on an outing to the Big Berger.

Store at Swiss

The little village of Swiss was built on the uplands south of Hermann on the Old Iron Road. The austere neoclassical detailing of the country store is relieved by the scalloped trim under the porch, a feature of many German buildings. The small boy to the left is perched on the mounting block, which was provided to help customers get on their horses or in their wagons. Five families from Switzerland had settled here and given the town its name.

The general store and St. John's Church were on one side of the road and the blacksmith shop on the other side; thus, farmers and travelers could have their horses shod while shopping and visiting. Country stores were the center of commerce and farm life at the turn of the century. They carried everything that might be needed by the country folk who came to purchase necessities, to pick up their mail, and to visit. South and west of Hermann were several similar little hamlets with country stores and churches. When the country stores closed, the sense of community in the settlement was often lost.

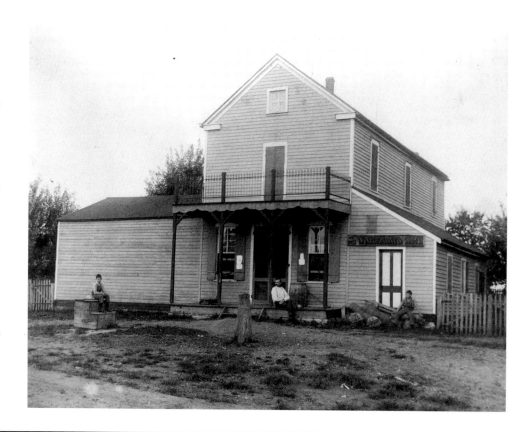

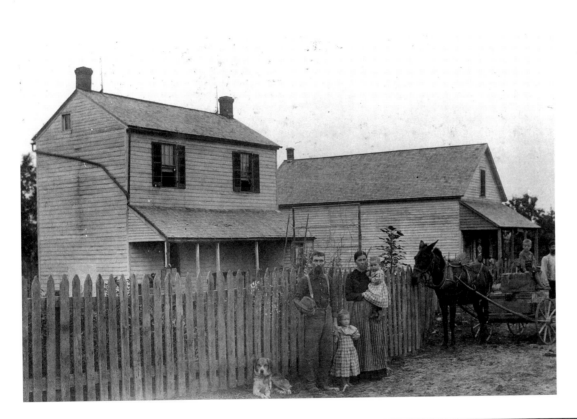

Stolpe Store and Post Office

Oldenburg was laid out by Jacob D. Schiefer in 1857 in a crescent around a bend in the Gasconade River, with the hope that it would become a city. However, it never expanded beyond a store and a few buildings. Later the general store, post office, and ferry were called Stolpe.

The two buildings reflect a simplicity typical of earlier rural immigrant settlements. Note the small windows in the eaves, suggesting that this is a log or half-timbered house which was later sided. The pent-roof porch was common in simpler two-story German houses. The chimneys were placed within the walls and not attached to the outside in the Anglo-American manner.

Stolpe Ferry

Those wanting to cross the Gasconade River at Stolpe had to ring the cast-iron bell and wait for Charles Ameling to come ferry them across. Here a team, a horse and a mule, pose with their owner, Henry Bohl. Ameling, who owned the store and ferry at Stolpe, is on the wagon with his family in this scene. Many creeks and small rivers had ferries that were pulled from one side to the other by manpower.

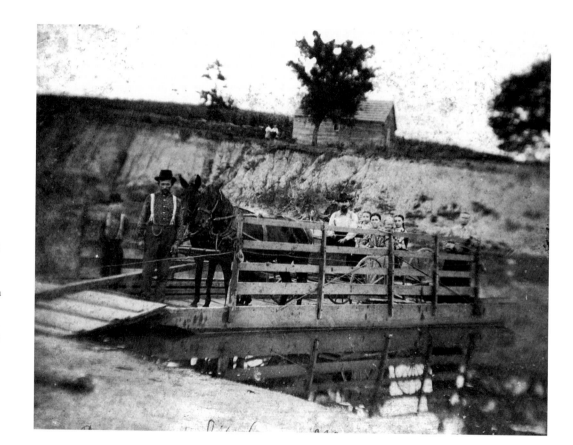

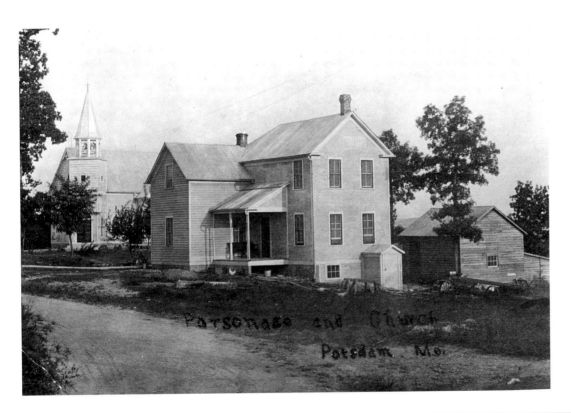

Parsonage and Church
Potsdam, Mo.

Potsdam

Across the Gasconade River was the Potsdam store, post office, and church. In 1918, during the height of anti-German hysteria of World War I, the town's name was changed to Pershing in honor of General John J. Pershing, Commanding Officer of the American Expeditionary Forces in France and a native of Linn County, Missouri.

Gebler Store

John Breeding settled in the First Creek area in about 1820. In 1886, Samuel Sutter, cousin of John Sutter of gold rush fame, started a general store in the area and served as the first postmaster. He soon sold it to William S. Gaebler, who owned it from 1892 to 1899, and the area became known as Gebler when the postal service misspelled the name. This early settlement also had Trautwein's Mill, a blacksmith shop operated by Gottfried Ulrich, and a Presbyterian Church, built in 1858. All church services were conducted in the German language until 1930. The post office closed in 1901 when Rural Free Delivery became available to the community, but the store continued and became known as Feil's Store. Edward Kemper's daughters are standing on the porch.

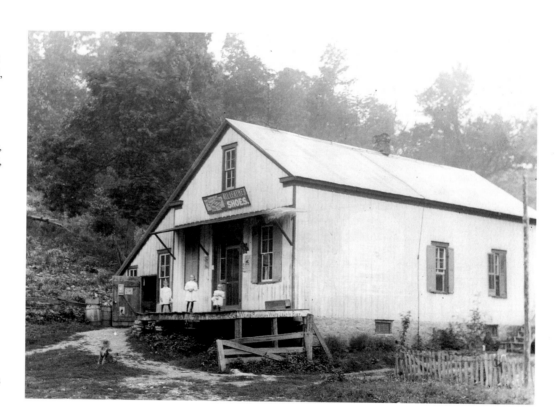

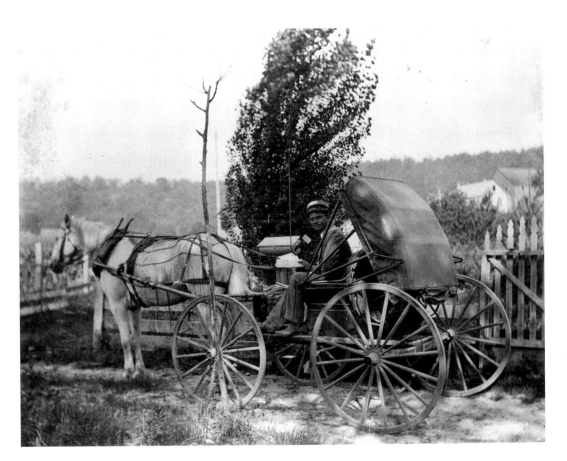

Rural Mail Delivery

Gustav Fischer was the first mail carrier on the rural free delivery route to the Frene Creek, First Creek, and Stolpe areas. On his first day on the job, Kemper met him at the mailbox and took his picture. Note the fly net on the horse's back and sides and the curving top of the double-heart picket gate to the Kemper farm.

Logging

Timber provided extra income for landowners, and the Kemper farm had an abundance of trees. In this photograph, Kemper demonstrated the large size of the trees by posing one of the men against a particularly large log. Note the steam engine powering the sawmill.

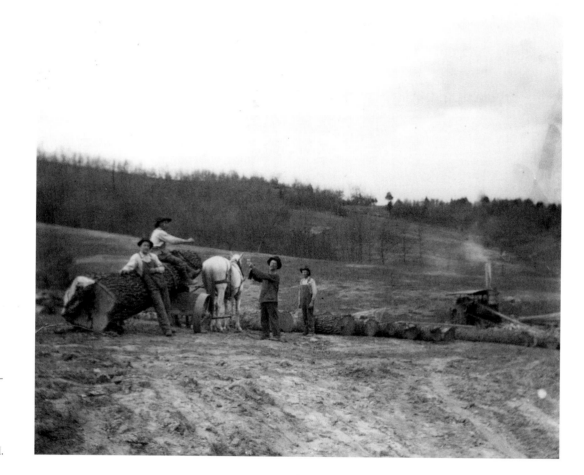

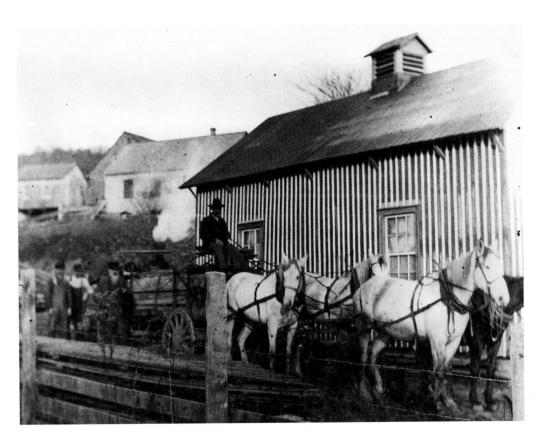

Hauling the Lumber

Sawed lumber was hauled to Hermann for sale or sometimes shipped by rail or floated on the Gasconade. The wagon and team are shown beside the board-and-batten packing house for the Hermann Grape Nurseries. The packing house on the Kemper farm, the building in the foreground, was built about 1896 and stood on a two-foot underground foundation. The outside walls were of two-by-six upright siding, with strips painted white placed over the cracks. The inside was boarded over and the space in between filled with sawdust. A ventilating shaft topped by a cupola ran from the floor through the roof. Temperatures within never dropped below freezing. One- and two-year-old grape plants were stored in the packing house in the fall and packed for shipment in the spring. Kemper shipped wine rootstock to customers around the world.

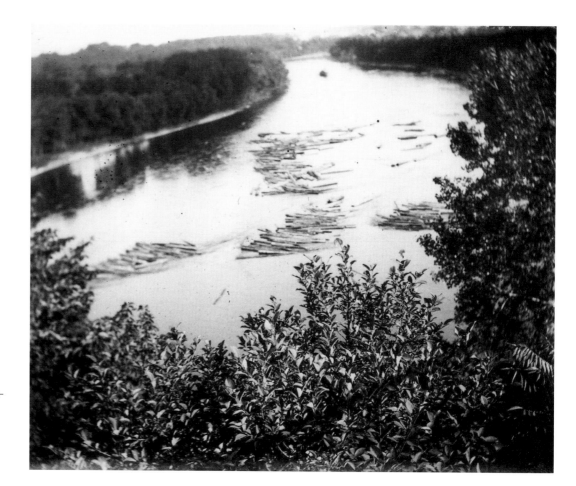

Logs on the Gasconade

The Gasconade River was a major water route from southern Missouri and served as a freight and log conduit for generations. Here, pine logs are being rafted down the river about 1900.

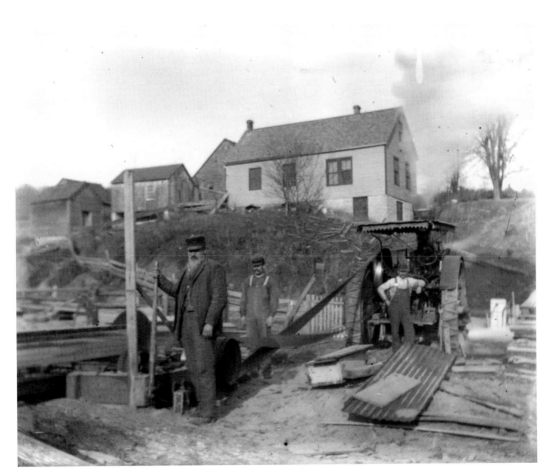

Selling the Sawmill

Because he no longer needed it, Kemper advertised his Fischer and Davis sawmill, complete with log wagon, for sale in 1906. Standing in front are Fritz and Henry Gaertner, the men who handled the rig. Kemper became interested in a variety of businesses during his long life; milling and planing oak flooring was one.

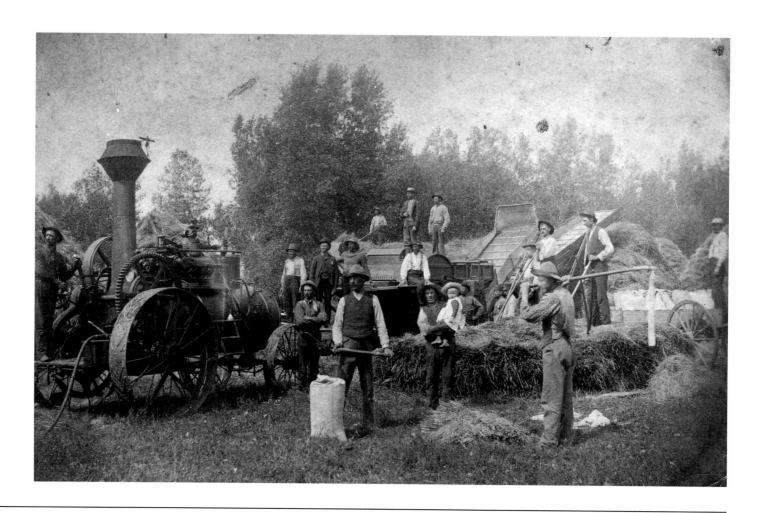

Threshing Crew

The cultural, geographic, and settlement factors that made it possible for Hermann to preserve its language and traditions for almost a century may also be responsible to some extent for the continuance of Old World agricultural practices in the area. Stack threshing, with the aid of an itinerant threshing rig, became popular in the mid-1850s, but researchers have found that settlers in Gasconade County flail-threshed grain crops well into the end of the nineteenth century.

Kemper, welcoming the new technology when it came, wanted to show the changes occurring with mechanization. In this photograph, the man posing with the flail in the foreground demonstrates the old harvesting technique, with one bag of grain to show for it. In the background a steam thresher and other equipment illustrate what the modern farmer of 1900 could accomplish.

For an early machine such as this, bundles of grain brought from the fields had to be cut before being fed into the separator, the straw had to be removed by hand as it shook out the back, and straw stacks had to be built by hand. With later separators whole bundles could be thrown into the machines—a task requiring considerable skill—and the straw was blown out the back. When a young man was promoted to throwing bundles, grain heads first, into the separator, he thought he had "made the grade." The blower operator, usually a member of the threshing crew, had to build the straw stack so it would turn water, starting away from himself and building back toward himself. Some landowners, including Edward Kemper, had a frame shed near the barn, and straw was stacked over it to provide additional shelter for livestock. Most of the grain was sacked as it came out of the separator and had to be carried to the granary.

There were several local operators in Gasconade County, and farmers did not have to depend on itinerant threshing crews from outside. The threshing was done by "runs"—the Frene Creek run, the Coles Creek run, the First Creek run, and the Iron Road run. The Kempers were on the Old Iron Road, and their operator was usually Karl Buschmeyer, known as "Dresher Karl" ("Thresherman Karl").

Those farmers on a particular run helped as their neighbors' grain was threshed, bringing teams to haul the bundles of grain from the fields or providing labor. Records were kept so that the work was as evenly divided as possible.

When the thresherman decided it was dry enough to thresh, he blew his steam-engine whistle, which could be heard for miles, to let the first farmer on the run know that threshing would begin. Farm women had to be ready to provide the expected meals (while at the same time helping carry water to the fields for the threshing crew). Eating was an important aspect of the threshing day schedule. "Lunch" was served around 10 A.M., there was a noon meal, and lunch was ready again at 3 or 4 P.M. Meals were sumptuous—two kinds of meat, potatoes, at least three vegetables, homemade bread, butter and jelly, pie, and coffee. The men on the crew knew who fed the best as well as those who were a little stingy. There was competition among most of the women to be known as "good feeders," except for those who were stingy enough not to care.

Steam threshing was noisy, and the teams of horses had to be able to tolerate noise and movement—or they would have to be unhitched and the wagons of grain pulled by hand from the field. Wood and water had to be provided for the engine by the host farmer. There was always danger of fire from the embers thrown out by the engine, and women and children had to be ready to help. Families were always relieved when the work was finished and the thresherman blew his whistle to let the next family know to expect him.

**Taking Grain
to Market**

Delivering grain to
the grain elevator
was a familiar scene
throughout the
Midwest. Wooden
elevators like this one
are now largely gone.
This photograph was
probably taken on
one of Kemper's trips
to visit family.

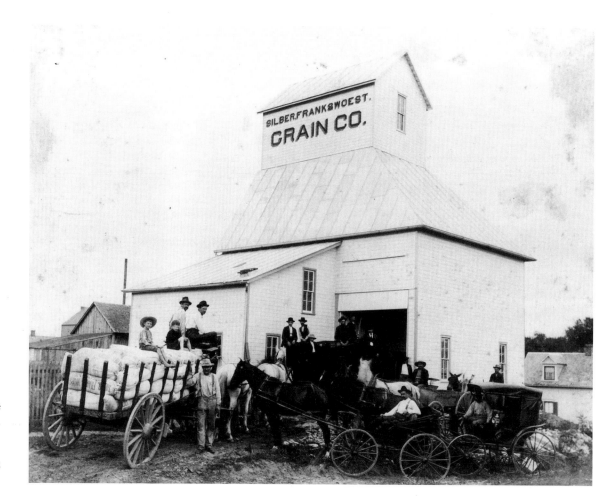

Kemperhof with Checkrows

A winter view of the Kemper farm was again an opportunity to show something modern and up to date. The corn stubble in the foreground indicates the field was planted using a checkrow device, which permitted cultivation both between and across rows—the latest technique for achieving optimal crops in 1900. The arrangement of the farm buildings is strongly reminiscent of the Kemperhof in Schoenemark, Germany, from which Christoph Kemper emigrated.

Kemper Barn

By 1912, the Kemper farm required a bigger barn for its hay, grain, and cattle. The old barn, which had been built by Christoph Kemper in the early 1850s, was carefully dismantled so that the heavy timbers could be reused in the new barn. The original, half-timbered barn had included an enclosed grain storage room or *Speicher,* which at times was used for storing grain and at other times served as a schoolroom when itinerant preachers would pause for a week or two to conduct school, provide religious instruction for the children in the neighborhood, and officiate at baptisms and marriages.

The photograph is remarkable for showing evidence of traditional construction for thatching. Note the horizontal rods along the roof.

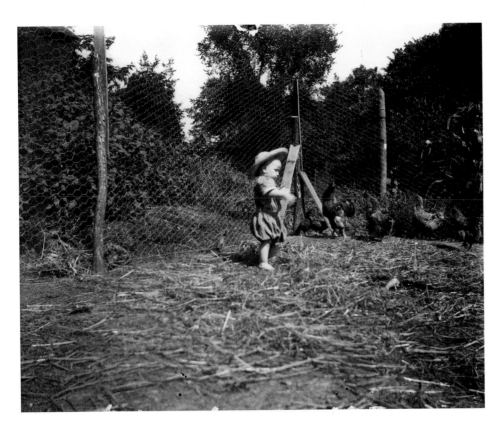

**Feeding the Chickens
at the Gaebler Farm**

Farm children learned to help with chores
at an early age, but barefooted Herbert
Ulrich is probably feeding the chickens for
fun in this photograph taken during a sum-
mer visit to his grandfather's farm. Fritz
Gaebler's children enjoyed bringing their
families to visit their old home in First
Creek valley.

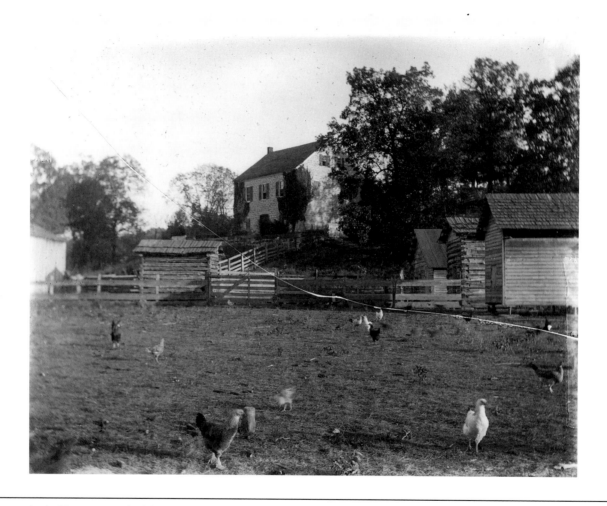

Fritz Gaebler Home

By 1846 Fritz Gaebler, who had come to Hermann with his parents in 1839, had joined the U.S. Army to fight in the Mexican War. He was assigned to teamster duty, and with a six-mule team he hauled army supplies and provisions a thousand miles across the plains to Santa Fe. There he was placed with the mounted artillery and took part in two major battles. He was in Chihuahua when the news of peace arrived, and he was discharged from service at New Orleans. When he arrived back in Hermann in 1849, Hans Sutter, a neighbor, had just received news that gold had been discovered on the land of his cousin, John A. Sutter, in California. Gold fever struck many of the young men of Hermann, including Fritz Gaebler, his brother Ernst, George Husmann, and about seventy others who left for California as soon as they could get ready for the trip.

In a letter home Fritz reported that at first his group did poorly in their panning for gold: "from 2 ½ to $4 a day, twice $6 for the five of us in a day and for that we had to pay $2.50 daily for water." Their luck later improved and they were able to send money home with friends until they could return themselves. When gold mining did not prove as prof-itable as he had hoped, Fritz made his way back home and drove a herd of cattle to California to sell in the mining camps.

After his return to Hermann, Fritz Gaebler married Caroline Gentner and settled at his home on First Creek. Caroline died in childbirth, and a few years later he married Wilhelmine Ronneburger. In the fall of 1864, when Fritz was serving with the Volunteers at Jefferson City and Wilhelmine was at home with three small children, a group of Confederate officers in the vanguard of General Price's army camped at Trautwein Mill. They came to the Gaebler house and asked Wilhelmine for a home-cooked meal. She prepared the food with sons Charles and William clinging to her skirts and a baby daughter on her arm. After the officers ate, they thanked her profusely before leaving.

Fritz Gaebler's rock house was built in 1849 after his return from California, with the help of his neighbor August Hesse. It is one of the largest of the early stone houses built by German settlers in the Hermann area. The view is across the farmyard from the bottom of the hill. Note the log buildings and the stone supports under the granary on the right.

**Demonstrating Latest Lawn
Mower Technology**

Before reel mowers were readily
available, grass had to be cut with
a sickle or a scythe, such as the
man on the left holds. In these
photos, dating from about 1900,
mower and grass catcher are
demonstrated to the Kemper fam-
ily and visitors. The trim on the
porch in the background is
notable: at least three paint colors
were used to decorate the details.

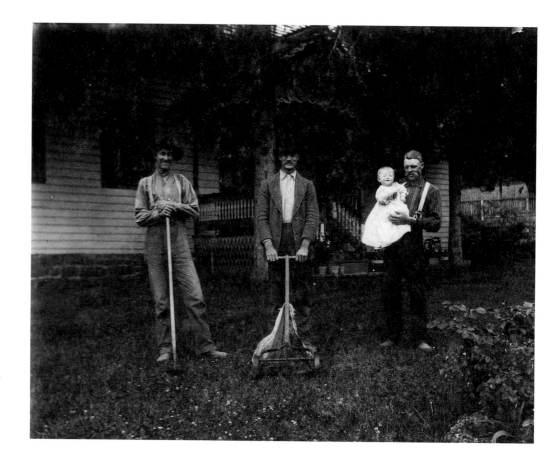

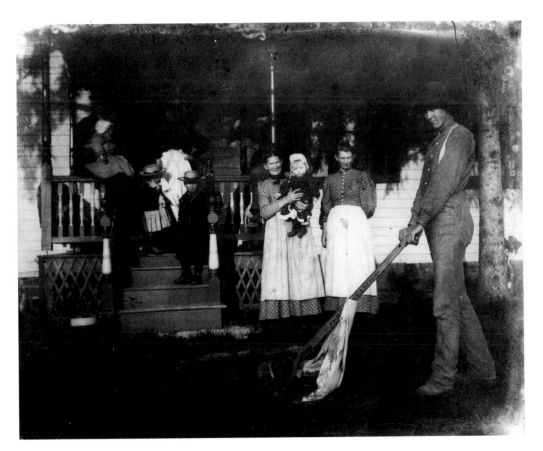

The Grass Catcher

As more family members gather around to admire the new acquisition, the grass catcher is featured in a photograph.

Few rural homes had lawns at the turn of the century, but neighbors remember that Edward Kemper's home was a showplace, with a lawn, shrubbery garden, flowers, and neatly kept vegetable garden.

The new push lawn mower was heavy, and it was "quite a job" to mow the lawn—but it was progress!

Early Car Travel

Edward Kemper bought his first Ford in 1911; at that time, the speed limit in Hermann was eight miles an hour. Horses frightened by the noise of the motor sometimes exceeded the speed of the car, and automobile drivers learned to pull to the side of the road, shut off the motor, and wait for horses and buggies to pass. Another problem was caused by Hermann's hills. When the gasoline in the tank under the front seat was low, the driver had to turn the car around and back up hills.

In 1912, when Kemper traveled to Diehlstadt in Scott County in southeast Missouri on business with the Diehl Lumber Mill, he was often asked if he was a road builder. The photograph vividly conveys the state of the roads he traveled.

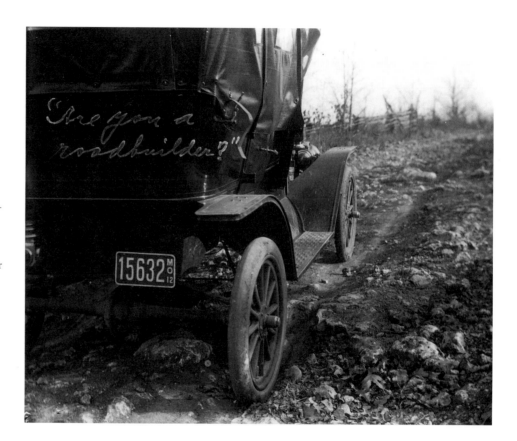

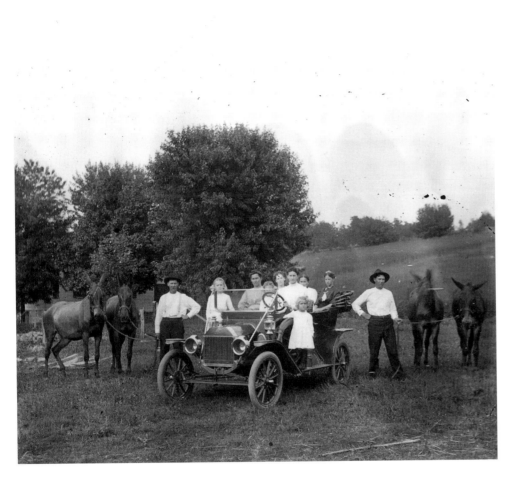

Car versus Mules

In spite of frequent flat tires and other problems, Kemper was pleased with his car and applied to become a Ford sales representative in 1915. He immediately received a contract for a territory including Roark, Richland, Boulware, and Boeuf townships in Gasconade County, Lower Loutre in Montgomery County, and Bridgeport in Warren County. The company estimated he would need fifty cars for his territory and sent them; he had to build a tin shelter for the cars before he could begin demonstrating the advantages of car ownership to his neighbors.

Here a sales presentation to a neighbor is recorded by a photo showing the new car flanked by mules, the old ways giving way to the new, with the entire family witnessing the event. Anna Kemper is in the driver's seat and the children and neighbors are gathered around. But how do you persuade a man to buy a car when he has four mules that do all his farmwork, take him to the store and to church, and are always ready to go? Kemper's ledger at the Western Historical Manuscript Collection indicates that he did not continue in the car business after 1915.

Ford Building in Hermann

By about 1920 Hermann had a
Ford agency. Even with the
unpaved streets of the time there
was an enormous difference in the
Hermann of the second decade of
the twentieth century and the ear-
lier Hermann of the Wharf Street
scene. The building at Market and
Fourth is largely unchanged today,
but the leafy trees and the early gas
pump are gone, and the streets are
now paved.

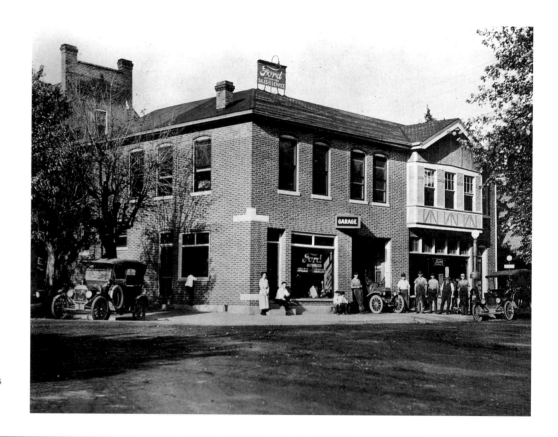

II

The Vineyards

Hermann was an early leader in the development of the wine industry in Missouri, and its viticulturists produced large quantities of excellent wines at many different times in its history, beginning in the early 1840s. Biographer and historian Linda Walker Stevens of Hermann has written that the year 1843 was an important one for the future of Hermann's wine production. "Hans Widersprecher procured a slip of Norton's Virginia Seedling from . . . Cincinnati, and planted it in his Hermann garden, where it prospered. Jacob Rommel . . . saw the vine's potential in 1846. He made the first Norton wine in Hermann in 1848, and was the first grower in Hermann to propagate the grape extensively, beginning around 1850."[1]

Count Adelbert von Baudissin, who was living in Portland in the 1850s, reported that the abundance of grapes growing wild in the area and the soil rich in lime near Hermann had led to the belief that a "noble wine" could be produced there. He noted that for that reason, many German settlers were drawn to the city and the "farms stretching like a belt around it." Although, according to Baudissin, some early settlers grew discouraged and left before there was the prospect of a grape harvest, he reported that the events of 1848 had brought renewed encouragement for those who had stayed.

The year 1848, so rich in events, was for Hermann's vineyards a truly blessed year; all vines were covered with the most beautiful grapes, the freshly pressed juice was bought at high prices by the Americans, so proud of the products of their land, and vintners who had $3/4$ of an acre planted took in $2,000.[2]

1. Linda Walker Stevens, "The Story of Wine at Hermann," 2.

2. Adelbert Baudissin, *Der Ansiedler im Missouri Staate,* 89.

Hermann celebrated the bounty of the 1848 grape harvest with its first *Weinfest*. Observer Gert Goebel reported that the news of the successful harvest had spread all over Missouri "as far as the German language was spoken," and visitors, ladies and gentlemen, had come from St. Louis on steamboats to participate in the celebration. As Goebel, who was himself drawn to the festivities, approached Hermann toward evening, he heard a "six-pounder, which was posted on a prominence in the town, tender its salute to the winegrowers, its thundering voice reverberating over hills and valleys."[3] A celebratory parade was held, led by a brass band and a large wagon drawn by four white horses. A local resident playing Bacchus, god of wine, wore a crown of grapes and stood on the wagon next to a large cask of wine, a sight that must have amazed American visitors at the festival.[4] The procession wound past the vineyards so that celebrants could view the splendor of the harvest for themselves. To Goebel, the trellises seemed to be nothing but solid walls of grapes.

Baudissin wrote that the successes of the 1848 harvest "ran like wildfire through all of America and the general password was 'Hermann.'"[5] The population increased quickly as many of the friends and relatives of the people who had emigrated earlier heard the news and more vineyards were established. Although a succession of bad years followed 1848 as several varieties of grapes became susceptible to disease, insects, and rot, grape growers in Hermann continually experimented with new and more reliable varieties, eventually enabling the wine industry to gain a solid footing.

In conjunction with the developing wine industry, grape culture became an important aspect of Hermann's economic stability, and during the years of its development and growth, the continuous research and experimentation carried out by the growers were rewarded with significant successes. Many new varieties of grapes better adapted to the Hermann environment and hardier than the older native and European varieties were developed. Through experimentation with seedlings of different varieties, cross-pollination and hybridization, the viticulturists, working carefully and persistently, achieved impressive results and gained enough attention to be listed in grape growers' catalogs and recognized in such works as *The Grapes of New York,* published by the State of New York Department of Agriculture in 1908, "to record the state of development of American grapes."[6]

3. Gert Goebel, *Länger als ein Menschenleben in Missouri* (St. Louis: C. Witter [1877]), 142, as quoted by Bek, "The Followers of Duden," 332.
4. Stevens, "Story of Wine at Hermann," quoting William A. Helffrich, *Lebensbild aus dem Pennsylvanisch-Deutschen Predigerstand: Oder Wahrheit in Licht und Schatten,* trans. Raymond E. Hollenbach (Allentown, Pa.: N. W. A. and W. U. Helffrich, 1906), 6.

5. Baudissin, *Der Ansiedler im Missouri-Staate,* 90.
6. U. P. Hedrick, *The Grapes of New York,* v.

Among the first professional grape growers in Hermann was Carl Teubner, who established a commercial wine grape nursery just east of town in 1847, the same year that wine growers and vintners Franz Jacob Langendoerfer and Michael Poeschel planted their vineyards. The man who became foremost among the largely self-taught experts Hermann could claim was George Husmann, one of the greatest pioneers in the development of the U.S. wine industry in the nineteenth century. Husmann came to the United States with his parents, Martin Husmann and Louise Charlotte Wesselhoeft, in 1837. Martin Husmann had bought shares in the Philadelphia Settlement Society before leaving Germany, and he came to Missouri shortly after George Bayer was sent to purchase land for the colony. Buying property east of the colony site from the federal government, he set out to establish a home for his family there, only later claiming his lots in Hermann.[7]

George Husmann spent his youth working on his father's farm and with his brother-in-law Carl Teubner, learning all he could about wine-grape culture. He established businesses of his own in Missouri and wrote extensively on grape growing. His book, *The Cultivation of the Native Grape and Manufacture of American Wines,* published in New York in 1866, was revised and reprinted several times. In 1869 he founded and published the *American Grape Culturist,* which at the time was the only periodical in the United States concerned exclusively with grape culture and wine making. In the 1870s, when the vineyards of France were virtually destroyed by phylloxera (root louse) infestations, Husmann joined other Missouri grape growers in sending thousands of grape plants to enable French growers to graft and hybridize French vines with Missouri rootstock to develop a vine resistant to the root louse. During his years in Missouri—in Hermann, Bluffton, Sedalia, and at the University of Missouri—and after he moved to California in 1881, Husmann maintained close friendships with former neighbors in Hermann interested in growing and improving the grape and served as mentor and model to younger viticulturists. His contributions to the grape industry through experimentation, promotion, and publication were enormous.

In November 1845, "a group encompassing almost every well-to-do professional, merchant, and artisan"—Hermann's winegrowers—"formed the first farm organization in the United States devoted entirely to viticulture."[8] Among the early settlers of the Hermann area who devoted their lives to improving grape culture were men of varied backgrounds who accommodated quickly to the new environment. Jacob Rommel, a baker from Wuerttemberg, and his wife Caroline, a native of France, established their home and vineyard in the

7. Linda Walker Stevens, "The Making of a Superior Immigrant," 124. This solidly researched article, based on Husmann family papers and other sources, provides detailed accounts of the Husmann family in Germany and the United States.

8. Linda Walker Stevens, "Hermann, Missouri: Pearl of Great Price."

southern part of Hermann in 1838. E. B. Trail, a Washington, Missouri, historian, has written of Rommel: "Horticulture seems to have been the highlight of this man's life, and the achievement of Jacob Rommel with his grapes makes a record that will endure for many years." According to Trail, Rommel had been with the first members of the Philadelphia Settlement Society to arrive in Missouri, but he missed the steamboat that took the settlers to Hermann in December 1837. Undaunted, he set out on foot through the wilderness for the new settlement, arriving safely in a few days and spending his first night in a chicken coop near a log shanty on the site of the future settlement. He is said to have built the first hewn log house constructed in Hermann. Trail wrote:

> Jacob Rommel had notable success in grape culture and the production of fine wines in Hermann. When George Riefenstahl brought tiny Norton's Virginia seedling rootlets to Hermann Jacob nurtured them and they grew into splendid grape stock, the grapes producing a heavy red wine in high favor with the many French families in St. Louis, and Rommel's wine was in great demand there. His white wines were produced by mixing white grapes in different proportions, and wines of exquisite flavor were thus developed. All of his white wines were shipped to New York where the demand was always greater than the supply.[9]

9. E. B. Trail, "Jacob Rommel," TS in Anna Hesse papers, Western Historical Manuscript Collection. Georg Conrad Riefenstahl, his wife,

Jacob Rommel Jr. followed closely in his father's footsteps in experimenting with grape varieties. In 1860, as a young man, he moved to the hills at Morrison, Missouri, and entered into partnership with H. Sobbe to grow nursery stock and cultivate grapes. He hybridized Labrusca and Vulpina grapes so successfully that more than a dozen varieties he developed were still in use in the early twentieth century and rank high in the history of grape culture. *The Grapes of New York* reported on one of his discoveries:

> Elvira was originated by Jacob Rommel . . . from seed of Taylor which some say was pollinated by Martha. It was planted in 1863 and fruited for the first time in 1869. Bush & Son & Meissner introduced the variety in 1874. It was placed on the grape list of the American Pomological Society fruit catalog in 1881 where it is still retained. Its great popularity in Missouri was largely due to the energy with which it was advertised by certain prominent viticulturists, they having been most favorably impressed with it because of its withstanding the severe cold of the winter of 1873 without protection. Husmann, in particular, spoke of Elvira in the highest terms and recom-

and their five children were among the first seventeen members of the Philadelphia Settlement Society who arrived on the site of the Hermann Colony on December 6, 1837. Although Trail credits Riefenstahl, Stevens has found evidence that Hans Widersprecher brought the Norton's Virginia Seedling to Hermann.

mended its cultivation. Its popularity spread from Missouri to the islands and the Ohio shore of Lake Erie.[10]

At the beginning of the period when France was trying to save its vineyards, Elvira, according to wine historians, was used more or less as a resistant stock and somewhat as a direct producer, but by the early twentieth century was found in France only in varietal vineyards.

Rommel continued to experiment to develop a more perfect grape. "The tendency of the Elvira to crack and overbear caused the originator of that variety . . . to try for a grape without these faults and the result was Etta from seed of Elvira. It was first exhibited in 1879 as *Elvira Seedling No. 3*." From the seed of the Elvira, Rommel produced several varieties, including, in 1881, Faith, "an excellent grape" named to "honor Jacob Faith, a prominent Missouri viticulturist."[11]

Because midwestern grape growers were dissatisfied with the standard varieties then grown, which were mostly table grapes that were poorly adapted to wine making and Missouri conditions, Rommel continued to experiment and "originated many new varieties" more suitable for wine, among others "Amber, Beauty, Black Delaware, . . . Montefiore, Pearl, Transparent and Wilding," none designed for table grapes. His Etta (Riparia-Labrusca) was awarded the premium in 1880 by the Mississippi Horticultural Society in St. Louis as a seedling wine grape similar to Elvira in appearance. In Missouri, Etta, though not a good table grape, was generally considered a better grape than Elvira. The "Rommel" (Labrusca, Riparia, Vinifera) originated by T. V. Munson in 1885, was so named to commemorate the services to viticulture by Jacob Rommel.[12]

Among other Hermann grape growers and businesses recognized in *The Grapes of New York* for their achievement in developing new varieties were Nicholas Grein, Edward Kemper's Hermann Grape Nurseries, Franz Langendoerfer, Samuel Miller, and William Poeschel. Nicholas Grein settled on the ridge along the east side of the Gasconade River, the area first known as Oldenburg and later as Stolpe. Here he originated the Missouri Riesling (Riparia, Labrusca), Grein's Golden, and others. He believed that his Missouri Riesling (1870) was a seedling of the Riesling of Germany, but others thought it to be a Taylor Seedling. Missouri Riesling was placed on the grape list of the American Pomological Society in 1889 and was still listed in 1908. Grein's Golden was ranked with Missouri Riesling as the best of Nicholas Grein seedlings of Taylor in improvement over the parent variety. It was described as attractive, with both clusters and berries large and uniform, of an attractive gold color and producing a very good white wine.[13]

10. Hedrick, *Grapes of New York*, 260.
11. Ibid., 265, 270.

12. Ibid., 393.
13. Ibid., 282.

Franz Langendoerfer came to America from Baden in 1834 and in 1838 to Hermann, where he bought 360 acres of land in the upper region of Frene Creek valley. Here he built his house and planted several acres in grapes. In 1863 he built a rock wall in front of a cave in the bluff south of his house and used it as a wine cellar. His son August carried on the wine making, and, dissatisfied with the grape varieties available, worked with his father to propagate a number of wine grapes including Hermann, "a true Aestivalis";[14] it was brownish yellow and made a wine the color of brown sherry, which was considered of great body and fine flavor. They also propagated a White Norton (Aestivalis, Labrusca), which was vigorous, hardy, productive, and made a wine of golden yellow color; Taylor Bullit; and Missouri Bird Eye, which was free from rot in the Hermann area. The Langendoerfers built the St. Charles Wine Hall on Schiller Street, later known as "The Landing." Today one of the Langendoerfer hand-carved wine barrels is stored at the Hermann State Historic Site, *Deutschheim*.

Samuel Miller was a well-known grape breeder of Bluffton, across the river and west of Hermann. In the mid-1850s, while still in Pennsylvania, he developed the Martha (Labrusca, Vinifera), a seedling of the Concord. This at one time became the most popular of the green grapes and reportedly made a very good white wine. Miller was an advocate of close-breeding rather than cross-breeding as a means of improving the fruit.[15] His best-known varieties were Black Hawk, Eva, Macedonia, Martha, and Young America. Other varieties were Miller's Golden Beauty, a very handsome grape, and Woodruff's Red, "very showy and good." At the time of his death in 1901, Samuel Miller was working to improve the native persimmon.

Michael Poeschel, who came to Hermann in 1838 and later established the forerunner of the Stone Hill Winery, developed Poeschel Mammoth (Labrusca, Vinifera), a seedling of Mammoth Catawba, described as "healthy, cluster medium, berry very large, pulpy, deficient in flavor." Flower of Missouri (Labrusca, Bourquiniana, Vinifera), a Delaware seedling, was introduced by his brother William Poeschel.[16]

Christoph Kemper originated the Red Riesling (Aestivalis), which was introduced by the Hermann Grape Nurseries and listed in *The Grapes of New York*. It was described as being "hardy and free from rot; bunches medium, berries dark red and large." The Aroma (Labrusca), developed by Edward Kemper and listed in 1906 in the Hermann Grape Nursery catalog,

14. Ibid., 349. "Grein planted seeds of the European Riesling and of Taylor at the same time and he always supposed that none of the Taylor seed grew and that the Missouri Riesling was a seedling of the Riesling of Germany. Since the Missouri Riesling is evidently of Riparia-Labrusca lineage and shows no Vinifera whatever, it is to be presumed that Grein's labels were confused."

15. Ibid., 488.
16. Ibid., 501, 461.

was a new red variety, described as forming medium bunches, with very large berries, and a fine aroma.[17]

A recent survey of Hermann showed there were over sixty wineries in northern Gasconade County during the late nineteenth and early twentieth centuries,[18] each usually supported by its own vineyard. This number does not include the many garden vineyards in Hermann and its environs, which provided additional income to the owners when the grapes were sold to the large wineries, although it does indicate the extent to which Hermann's economy was supported by the grape and wine industries. Through the years Hermann vintners and wine growers won many awards: Pfautsch & Kuhn were recognized for the Best Rulander Wine; Dr. Ettmueller, Best Wine from Grein Seedling; Dr. E. H. Rhodius, Best Grapes; Francis Oncken, Best Grapes. Cynthiana, a grape highly regarded by George Husmann, was considered to be the best American grape for red wine and received a medal in Vienna for this category.

Whenever and wherever Hermann winegrowers gathered, the conversation soon turned to grape culture, its problems in Missouri, and possible solutions. Christoph Kemper was among the prominent early Hermann grape growers, and Edward

Kemper grew up hearing of the problems and concerns of viticulturists. Neighbors and friends involved in grape growing, its failures, successes, and promise, were almost daily visitors at his father's farm, and as a teenager he started growing grapevines for his neighbors. George Husmann saw that Edward Kemper shared his enthusiasm and love of grape culture, and after he moved to California in 1881, he kept in touch. He sent an inscribed copy of the fourth edition of his *American Grape Growing and Wine Making* to his young friend. In the book Husmann wrote:

> When I look back over life's checkered journey, at an age where many are called to join the silent army, the wish becomes natural to leave to those of my viticulture friends . . . especially to the beginner in grape culture, a memento of which I need not be ashamed. When I think of the time when I, as a youth of twenty, planted the first small vineyard I took charge of, on my Father's farm in the backwoods of Missouri in 1847, and find now that my pet fruit, the grape, has spread over the whole Union . . . that we have hundreds of varieties instead of three or four . . . the progress seems almost incredible. This is as it should be, and when we old men are gone, let us hope that our children, inspired by the same love of the work which urged us on, will take it as it drops from our hands and carry it to completion.

17. Ibid., 505, 435.
18. David Denman, "A Survey of Hermann," sponsored by the Missouri Department of Natural Resources, 1985-1987. A copy of the report is in the Scenic Regional Library in Hermann.

The Teubner–Husmann Wine House

This early press house and wine cellar was built by Carl Teubner in 1851, before his death in September of that year. Teubner had married Josephine Husmann in 1847, and when he died, George Husmann, who had gone to California to seek gold, returned to Hermann to help his sister with the property.

The wine house became an important part of the Husmann-Manwaring Nursery business in the succeeding years. The ground floor, recessed into the hill, is stone with a brick upper floor. The building had a raftered, not a vaulted, cellar and would once have had heavy straw insulation in the cellar's ceiling to keep the temperature constant.

In the fall of 1864, when the vanguard of General Price's army, under the leadership of General Marmaduke, camped on the winehouse grounds on their way to meet General Price at Jefferson City, they found the wine cellar, and, annoyed that there was no whiskey, opened all the barrels and let the wine flow down the hill into the Missouri River.

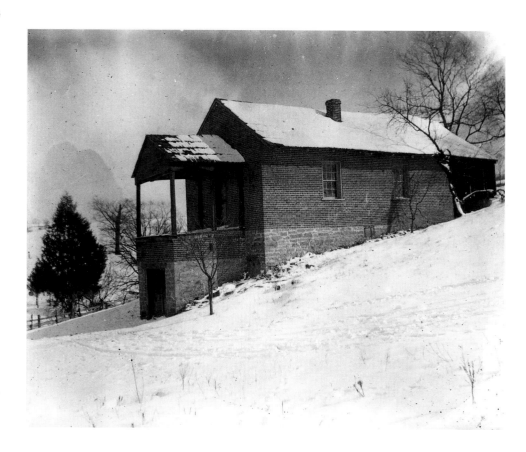

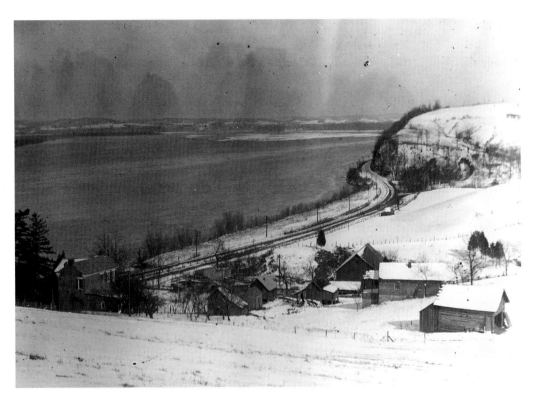

View of Husmann Wine House and Nursery

When George Husmann took charge of the Teubner property for his sister, he developed a nursery and fruit tree farm that became known throughout Missouri as a model business. Charles Manwaring joined Husmann as a partner in 1858. The nursery provided grape plants and fruit trees, along with a whole range of exotic plants—ginkgo from China, orange and lemon trees, and imported plants and seeds from Europe—to customers throughout the country. Husmann planted a ginkgo tree next to his sister's large brick home, which can be seen at the bottom left in the photograph. Almost a century later, in 1947, it was listed in the Missouri Botanical Garden *Bulletin* as the largest ginkgo in America. A busy highway now passes close to the house and tree, but the ginkgo still bears witness to the wide-ranging interests of a remarkable horticulturalist who made many contributions to Hermann.

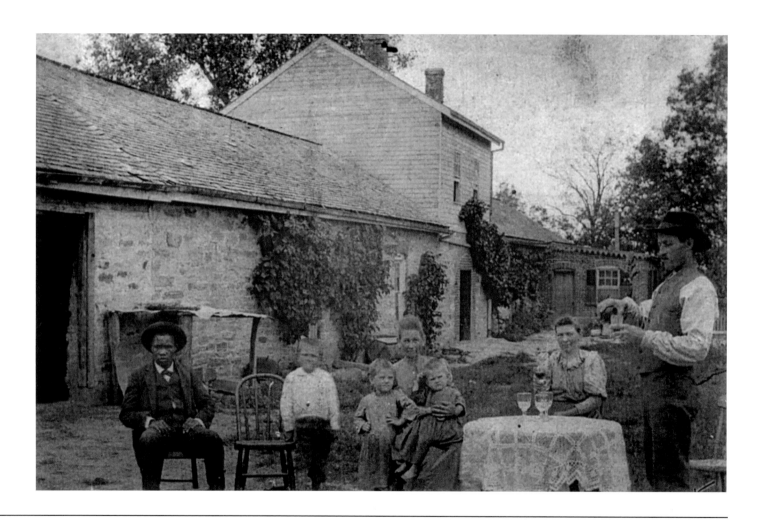

Husmann-Loehnig House-Barn

George Husmann bought this property in 1859 and hired August Loehnig, who emigrated in 1860, to manage the vineyard he planted there. The house winery was built in 1865–1866, and in 1869, when he invested in Bluffton, where the grape breeder Samuel Miller was working, Husmann sold the property to the Loehnig family. The building combined areas for wine production, a wine cellar, family quarters, and stalling for livestock. The *Stallhaus,* or house-barn, built of random rock, had an attic used for storing straw and hay and is attached to the former winery and living quarters of the house. Charles van Ravenswaay has noted that the original door of the wine house, wide enough to allow a wagon to be driven in, was later cut down and new brick facing installed.

At one time the property was called *Schau-ins-Land,* or "Look into the Country," because of its spectacular view. This early photograph of the house, wine house, and barn dates from the 1890s. (Courtesy Terry Loehnig.)

This is one of two Kemper photographs that show an African American. In 1890 Gasconade County had a population of 11,620 whites and 86 Negroes, but by 1900 there were 12,230 whites and only 68 Negroes.

Langendoerfer Cellar

This is one of the earliest and most famous wine cellars in Gasconade County, an enclosed cave behind Franz Langendoerfer's home in the upper east valley of Frene Creek. It is a fine illustration of a German immigrant's ability to adapt and use the resources at hand. The press house and other production areas built against the winery were added later. Note the years marked on the empty barrels to help the vintner keep track of the aging of his products. By the 1870s the Langendoerfers had ten carved wine casks for their product.

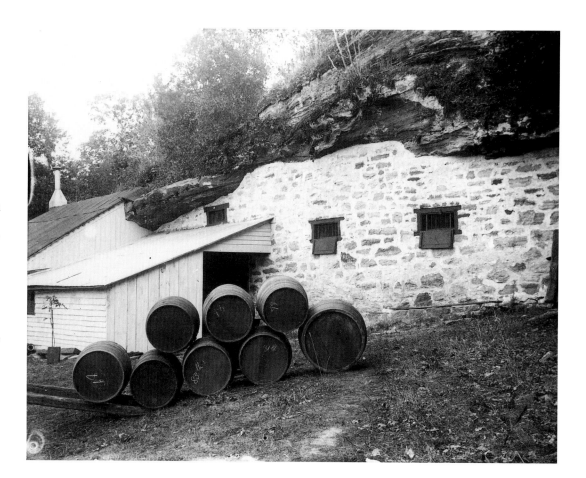

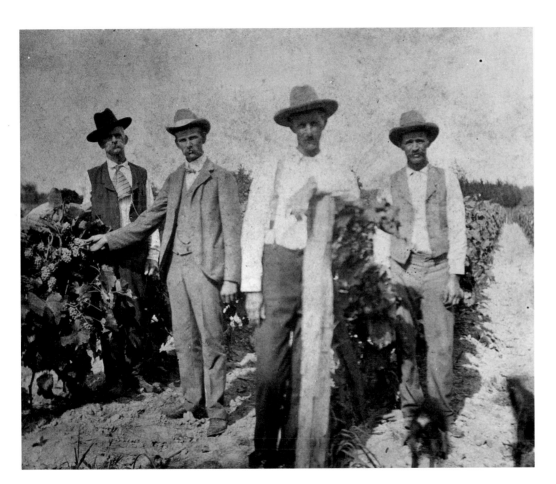

Robyn Brothers Vineyard

The Robyn family, which included gifted artists and musicians, came to Missouri in the 1830s and 1840s, following Wilhelm Robyn, who emigrated from Emmerich, a town near the Dutch border, to St. Louis in 1837 with his wife's family. Wilhelm Robyn became a founder of the St. Louis Symphony Orchestra and Edward was a well-known artist whose lithographs of Missouri River towns, including Hermann, Washington, and Jefferson City, were much admired. A second generation of Robyns established a large vineyard on the ridge off Highway H known as Dry Hill and developed the Dry Hill Beauty, "red, very sweet, an excellent table grape."

Edward Kemper, second from left in the photograph, bought cuttings from the Robyns for his business. Note the abundant production of the vines. Today no trace of the vineyard or its winery remains.

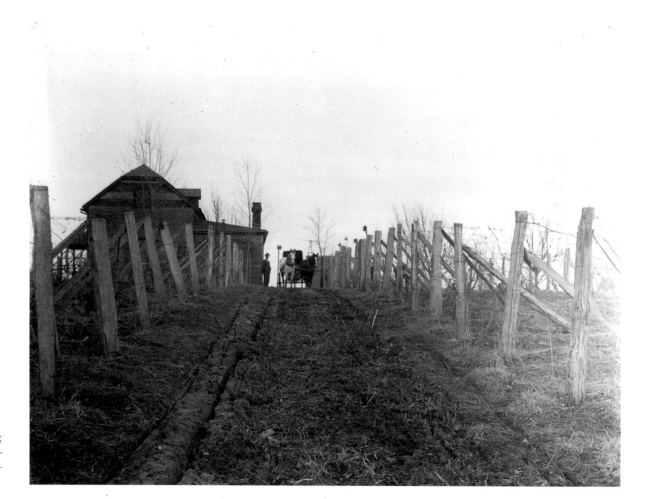

The Julius Ruediger Home and Vineyard

Julius Ruediger had a large vineyard on the high ridge between Coles Creek and First Creek, an area called Little Mountain. The house has a gambrel roof typical of many north German buildings. This view of the vineyard shows the vines growing to the very edge of the country lane. Note the many birdhouses on the fenceposts.

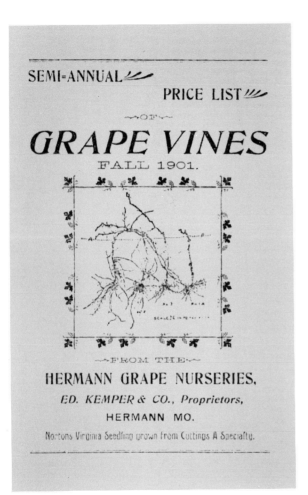

SEMI-ANNUAL
PRICE LIST
~OF~
GRAPE VINES
FALL 1901.

~FROM THE~
HERMANN GRAPE NURSERIES,
ED. KEMPER & CO., Proprietors,
HERMANN MO.
Nortons Virginia Seedling grown from Cuttings A Specialty.

Kemper Price List

In 1898 Edward Kemper started publishing annual price lists for his wine grapes in English and German. In his Hermann Grape Nurseries catalog he quoted one of the teachers at the University. "Our Horticultural Society secretary, Prof. Goodman, said to the State Horticultural Class in 1900: 'I think the people in the city should plant a few grape vines, if they had no other space to spare they could plant next to a woodshed or any other building, and let them grow up.'" Kemper gave his endorsement of these "wise words" and added that nothing could so improve the appearance of a backyard, often somewhat unsightly, than a few grapevines. "They bloom and bear and the great pleasure [is] to eat the fresh grapes direct from the vine." He advised readers to plant Moore's Early and Concord, black; Niagara and Martha, white; Marsala and Aroma, red. In the event that some customers did not want to plant near a building or along a walk, he provided a detailed plan for a trellis planting, with a photograph of a trellis. The directions he gave reflect his personal interest in grape culture and the hint of German grammar that distinguished his writing in English.

Kemper Vineyard in Spring

Caring for the vineyard was a year-round job. In 1903 Kemper spoke to the Horticulture Society on "Care of Vines" and illustrated his talk with carefully drawn sketches. He showed how to prune grape plants before planting, recommending as varieties the Elvira, which withstands cold winters, Red Riesling, which had been developed by his father, and Missouri Riesling. He showed a picture of the Aroma, which he himself had developed, "a chance seedling and in my opinion well worth a trial . . . very productive . . . does not rot . . . more a wine grape than for market . . . very aromatic." In 1905 he spoke to the same group on "What Varieties to Plant," giving practical advice based on his own experience. "I have found a great difference [in varieties] almost within a stone's throw. Close to large bodies of water, say along the Missouri River, any variety will do better than a few miles away. . . . Plant the old, well-known varieties and try a few of the new varieties."

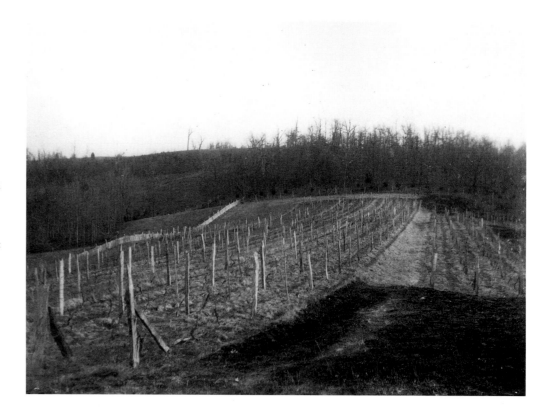

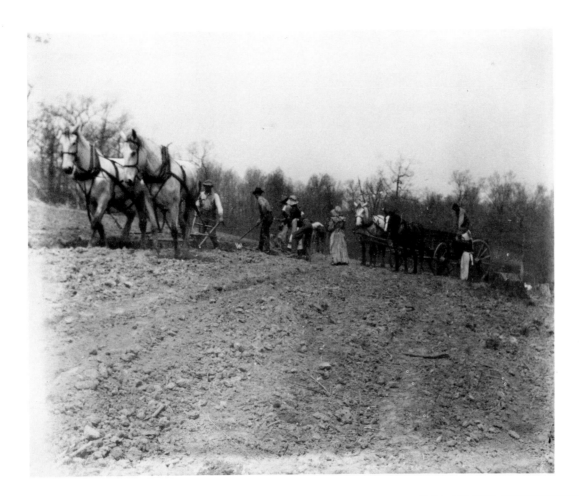

Preparing the Trenches

All grapevines were grown
from cuttings made during
the winter and tied into bun-
dles. Rows of deep furrows
were made with a special
plow, and the cuttings were
placed there and covered
with straw and soil.

Work Crew at Kemper Nurseries

These men and women, dressed in heavy work clothes, are preparing for a day's work in the fields planting grape cuttings. Sometimes there were over a hundred thousand cuttings to set out, and family, friends, and neighbors helped.

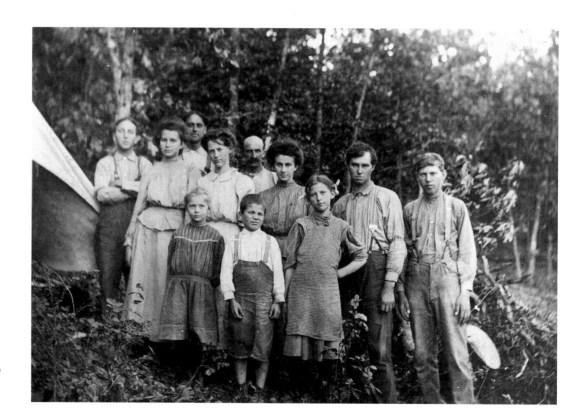

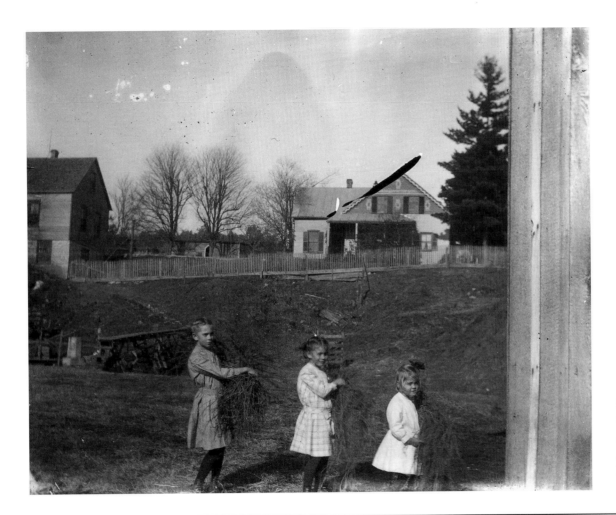

Kemper Girls with Grape Cuttings

The Kemper children, Edna, Esther, and Anna, worked with the adults. Edward's daughters are seen here carrying handfuls of grape cuttings.

Planting Grape Cuttings

All plants offered by the Hermann Grape
Nursery were grown from cuttings ten to
twelve inches long taken from the grapevine
during the winter. They were cut almost
through the bud at the lower end so that
roots could start more easily. Above the upper
bud about two inches were left so they
would not dry out. The cuttings were tied in
bundles of a hundred to two hundred each as
soon as cut and placed in a trench, fourteen
to fifteen inches deep, leveled at the bottom.
The lower bud of every cutting had to be on
the ground so roots could grow.

After the *drei Eisheiligen,* or the "Three
Icemen," May 11-13, the cuttings were set
out in nursery rows, in good soil that was
carefully prepared for the new plants. A deep
furrow was cut and cuttings set from two to
three inches apart with the upper buds even
with the ground and firmly packed. The rows
were two to three feet apart or one plow-
share wide. The crew is spread across the field,
which had been recently claimed from the
forest. Note the tree stumps dotting the slope.

The plantings were cultivated throughout the
summer to keep the soil open and porous. In
the fall they had to be dug, counted, tied in
bundles, and stored in the packing house.

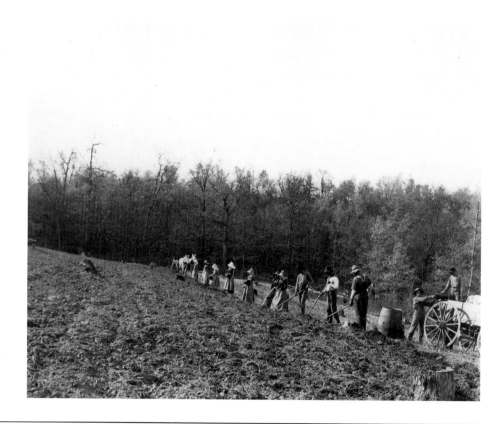

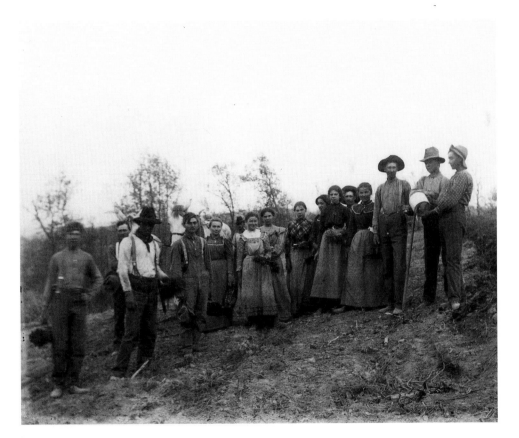

Work Crew Celebrating *Feierabend*

When work was done for the day, it was time to visit with fellow workers and perhaps pass around a jug of Kemper wine to celebrate quitting time, a custom known as *Feierabend.* Note that this photograph shows an African American man as part of the work crew.

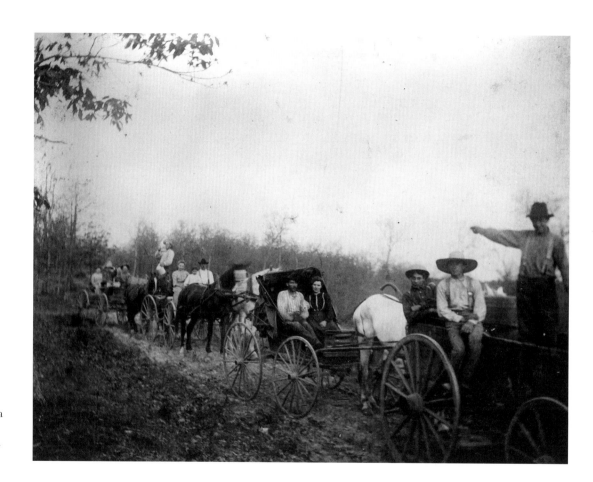

Work Crew Leaving

The work crew is on the way home from a day of planting cuttings. Pay was a dollar a day, a big dinner, and the jug of wine passed around at *Feierabend*.

Edward Kemper in Vineyard

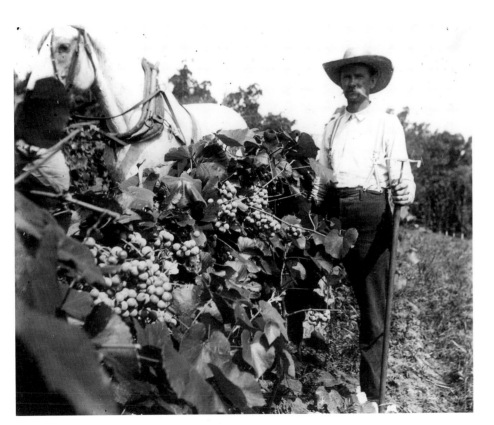

In this handsome self-portrait Edward Kemper is seen in his work clothes in late summer, when the vines are heavy with grapes. The grape pictured is the Aroma, which he developed in 1906. A striking image of hard work and pride in his accomplishments, this is one of Kemper's best photographs.

Kemper was often asked to speak to groups about grape culture. His talk on "Growing the Grape Vine" was published in the *44th Annual Report of the State Horticulture Society* of 1902. "Growing grapevines, planting and caring of the vineyard is something I have done since I was able to work," he said.

Years ago there were at Hermann more than a dozen wine growers that propagated vines, but they gave up one after another saying "This doesn't pay anymore!" They received 10, 20, 25 cents for each vine. Today nearly all the wine growers sell their cuttings to us; and if they are in need of vines they buy from us, very often asking: "How can you grow them at that price?" All I can answer is "Today you have to see that you get better results." We grow all vines from cuttings, including Norton's Virginia Seedling, Hermann, Cynthiana, Neosho, etc., which in former years was claimed could not be propagated from cuttings.

Ice Cream Social

In July, after all the planting was done, Kemper invited his workers to a picnic to celebrate. Beer, wine, and ice cream were served. Guests came in their best clothing, and each was given a corsage and all the ice cream they could eat. Ice cream was made with the last ice in the ice cellar. Sometimes the picnic was planned for July 4, a holiday dear to German Americans wherever they settled.

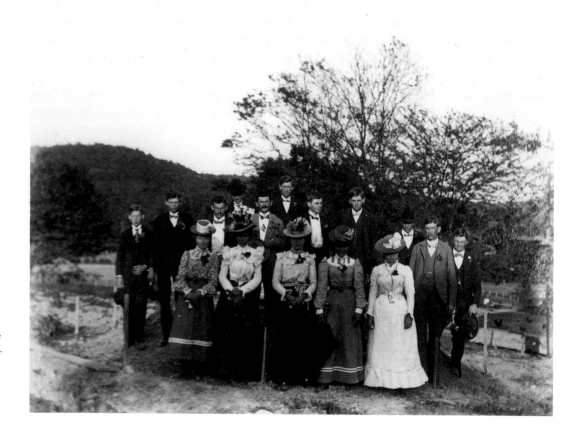

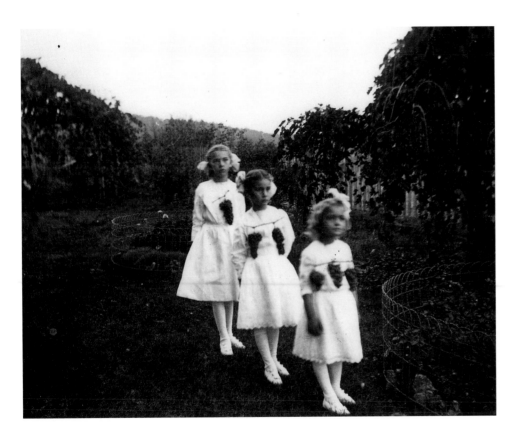

Girls Celebrating Grape Harvest

The three Kemper girls in their best
dresses wear bunches of grapes around
their necks: one, two, and three bunches
are carefully displayed. The girls pose in
the Kempers' luxuriant garden, surrounded
by rare plants. This photograph was pub-
lished in the 1913 *Standard Atlas of
Gasconade County.*

Rootstock

The vigor of these plants, shown against a world map, evokes Kemper's success and his wide-ranging business in one telling photograph. One of his specialties was fostering the difficult Virginia Seedling, which is still much in demand for its superior red wine.

Kemper developed a large mail-order business, shipping hundred of thousands of rootstock to Europe, Mexico, and throughout the United States. As his business grew, he and his helpers could not produce enough grape cuttings to supply the demand, and he turned to other grape growers in the area to provide cuttings for him. His records for one year indicate the extent of his business. From Langendoerfer, he had bought 6,300 cuttings, from Poeschel, 12,000, from Robyn, 3,400, from Romeiser, 6,000, from Schlemeyer, 6,000, and from Sexauer, 8,000.

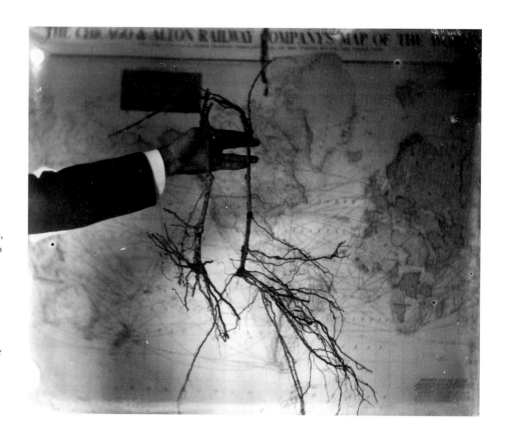

A FEW WORDS TO THOSE THAT LIVE IN THE CITY.

Following we give a plan if you don't want to plant near a building or along a walk; also a cut of the trellis work from a photograph.

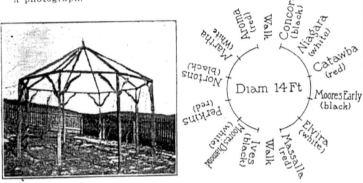

Plant as shown in above diagram. Save this circular and you will always be able to tell which is which. For prices of these vines see Special Offer "C." on another page of this circular. The trellis work is not needed the first year, can do without two years; have to drive small stakes to each vine. Remember, they need cultivation the first few years; also that they should not stand too close to large trees.

Sketch of Arbor Showing Varieties to Use

In his catalogs, Kemper promoted the use of grapevines on city lots and provided directions for homeowners for plantings around the grape arbor. His catalogs gave careful directions and encouragement to his customers.

**Celebrating
Hermann Wine**

The fruit of the Hermann grape was Hermann wine, and wine was both a business and a way of life. Whenever friends got together in town, there was always time for a glass of wine and a favorite toast: "Hoch soll er leben! Hoch soll er leben! Dreimal hoch! Er lebe hoch! Er lebe hoch! Dreimal hoch!"

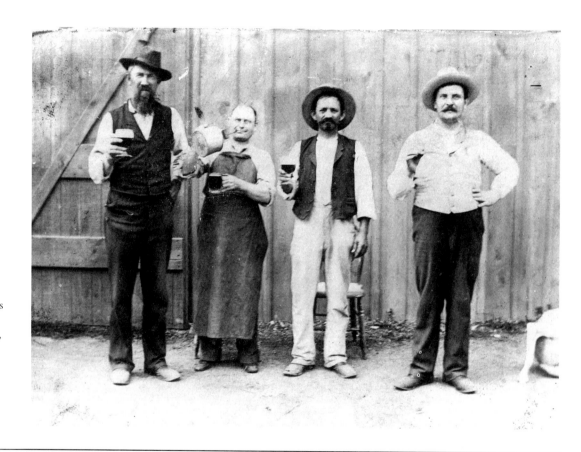

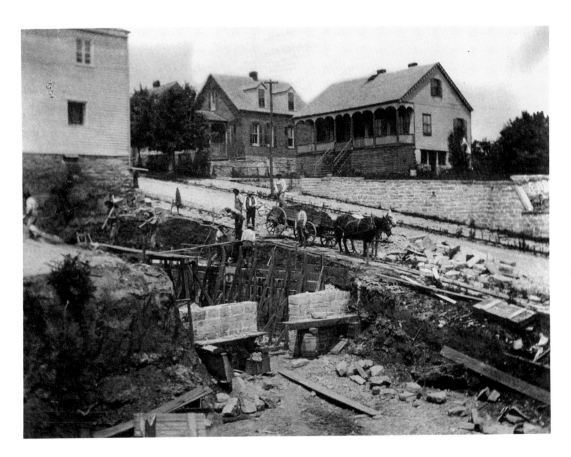

Building Sohns Wine Cellars

This photo details the early stages of construction of the Sohns Cellars on Market Street, revealing the massive size of the walls. In the background, note the stone retaining walls lining Fourth Street and the scalloped trim on the porch of the neighboring house.

Henry Sohns also had a lime-burning business in Hermann.

Keystone Ceremony, Sohns Winery

A number of townspeople and all the workmen gathered to celebrate the setting of the wine cellar's dated and embellished keystone, which can still be seen behind a building at Market and Fourth Streets. The date, 1903, and the firm's name are clearly legible.

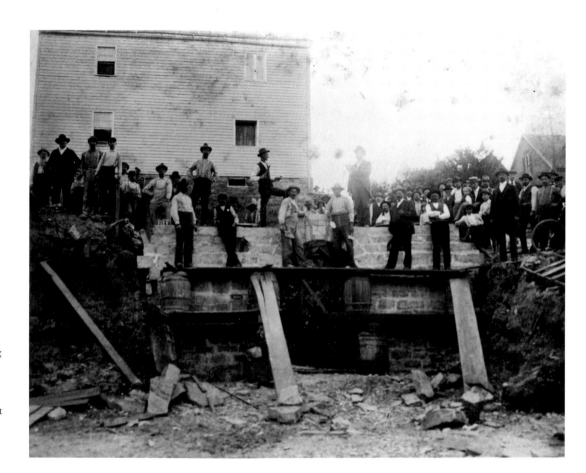

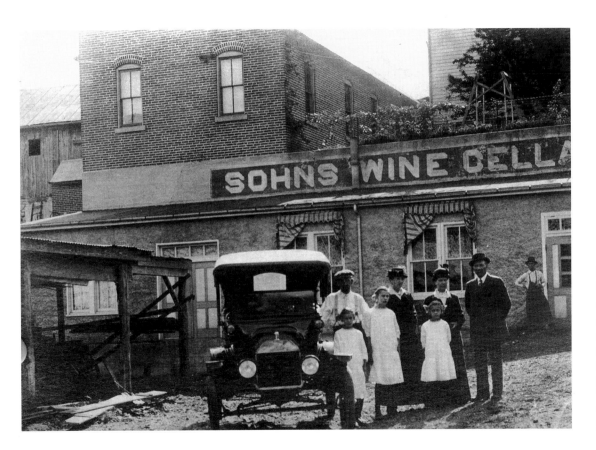

Sohns Wine Cellars Completed

The new Sohns business drew customers from the Hermann community as well as visitors from out of town. After Prohibition, the Sohns Wine Cellars were converted into an ice manufacturing plant.

Wine Tasting at Sohns Winery

A posed comic shot always gave Kemper a chance to include some of his favorite people. He also included a range of items needed in wine production in this photo: corkers, funnels, and specific gravity measurers to test alcoholic content, plus four of the wines produced by Sohns. The Virginia Seedling is still available in Hermann's wineries.

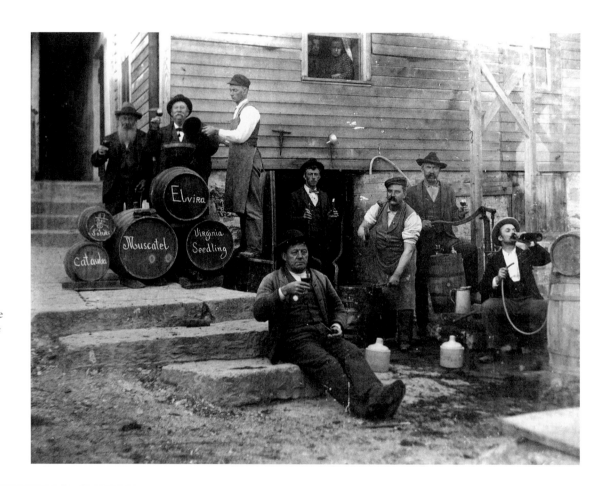

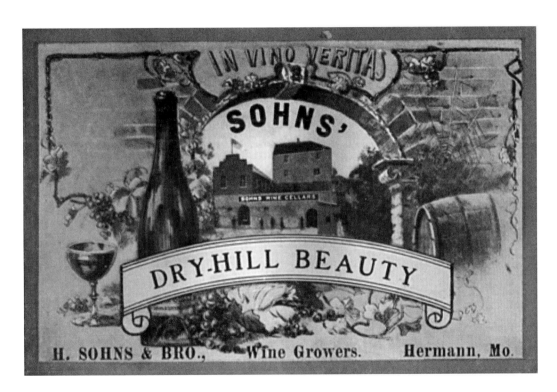

Sohns Wine Label

Henry Sohns, a native of Baden, had come to the United States in 1865 and lived for a time in Cincinnati and Aurora, Indiana. He came to Hermann in April 1866 and by 1869 or 1870 was engaged in the wine business. He had three acres in grape vines and in 1887 made 3,000 gallons of wine. As his business grew, he shipped wine to St. Louis, Chicago, and other cities. In addition to Dry-Hill Beauty, he made Virginia Seedling, Ives Seedling, Concord, and Sohns' Riesling. His wine labels are prized by collectors.

Husmann in California

Kemper's mentor, the viti-culturist George Husmann, gave up his professorship at the University of Missouri in Columbia to manage the huge Talcoa Vineyards in California's Napa Valley in 1881, when Edward was only ten. However, Husmann stayed in contact with the Kempers, sending Edward this photograph of himself in his own Chiles Valley vineyard. Note the massive fruiting of the vines closest to the camera. (Photograph from the collection of the State Historical Society of Missouri, a gift of Anna Hesse.)

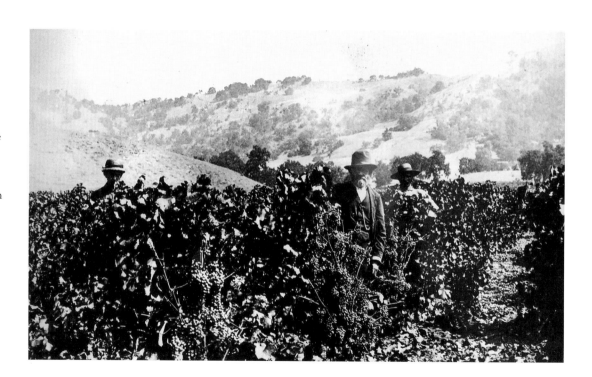

III

Customs and Traditions

Hermann's town plan and the cultural landscape of the settlements surrounding it are important keys to understanding the aspirations of its settlers and the traditions and values they sought to preserve. What have been called the "networks of associations,"[1] which in Hermann, as in other communities in the Midwest, were those of church, school, and family, are of equal significance. All contributed to the persistence of customary practices, the retention of language, and a sense of ethnic identity and provide insight into the cultural milieu of the area at the turn of the century. Charles van Ravenswaay concluded, "The dominant German population of Gasconade County ensured that German traditions would be more successfully transplanted there than in many of the neighboring counties and that they would be able to persist."[2] Geographical as well as settlement

factors also contributed to the survival of elements central to the ethnic identity of the community into the second half of the twentieth century. Hermann was uniquely situated within Gasconade County to permit the preservation of family and community traditions. These could remain relatively unaffected by the disapproval of nearby American settlers, who, William Bek notes, would have been shocked at some customs, particularly the practice of a "joyful Sabbath." Efforts of Missouri officials to regulate Sunday activities had persisted since the territorial period, when a law was passed setting a fine for working or providing services on Sunday. Throughout the nineteenth century, Sunday laws were revised and expanded to prohibit the sale of merchandise, theater performances, and recreational practices dear to German immigrants.

Fronted by the Missouri River, surrounded by the hills the early settlers had found so intransigent as they struggled to develop the town plan drawn in Philadelphia, and protected by ravines and

1. Carol K. Coburn, *Life at Four Corners: Religion, Gender, and Education in a German Lutheran Community, 1868-1945,* 4.

2. Van Ravenswaay, *Arts and Architecture,* 57.

cliffs, Hermann's location provided a hospitable space for Old World customs to continue to thrive. Bek, van Ravenswaay, and later researchers found evidence of a rich folk heritage surviving in pre-Lenten customs, Maypole dances and games, *Erntefeste* (Harvestfests) and *Schützenfeste* (shooting competitions). Many rituals associated with religious observances and the passages of life had survived. Some traditions and customs relating to death mentioned by van Ravenswaay are still practiced.

> Funeral notices, printed with heavy black borders, are still distributed to the stores to inform the townspeople of the services. Formerly the church bell was tolled on the death of a citizen: three times for an old person, and once for a young one. Until recently, when deaths occurred in homes, mirrors and pictures were covered until after the funeral.[3]

Both the survival of folk traditions and practices in Hermann and manifestations of high cultural aspirations reflected in musical and theatrical performances, literary clubs, and other intellectual pursuits have been well documented by academic and local historians.

Linda Walker Stevens noted that Hermann settlers brought the European belief in the virtues of the daily use of wine as a natural adjunct to food to their colony. They also brought a love of music, evident from the first *Musik Chor mit Blech Instrumenten* of 1839 to today's "Hungry Five" band and the musical Loehnig Family, who preserve instrumental music and song traditions going back to the earliest German immigrants to the New World. A *Musik Halle* was built on East Second Street in the late 1850s, and when that was outgrown about 1877, it was replaced by a *Concert Halle* on Front Street. Men's choirs and church choirs were instrumental in preserving German choral music into the twentieth century.

The Edward J. Kemper photographs confirm, in considerable detail, the cultural environment established by the early settlers and maintained by their descendants in agricultural, building, religious, and social practices. The customs and values of their forebears, transplanted and nurtured on the Missouri frontier, were reflected in their commitment to church, school, home, and community, which has left a lasting imprint on the Missouri cultural landscape.

3. Ibid., 56.

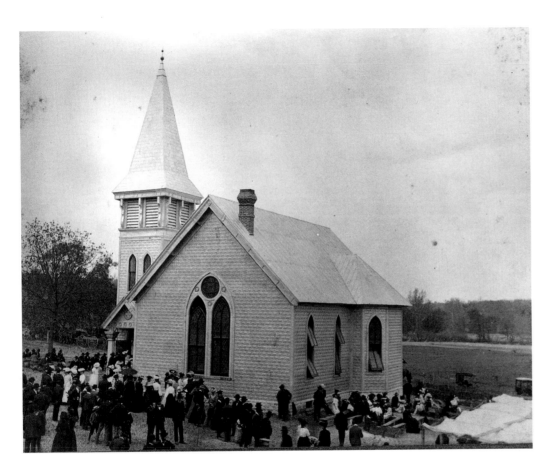

Zion Church, Bay, Missouri

Church activities were at the center of life for many devout German immigrants. The church social, with its food tents and tables as shown here, is still repeated at many country churches. Note the stamped tin siding on the church, a new material for exteriors, and the festive wear of attendees. In the early 1900s, men and women sat on different sides of the church during services. This church was dedicated in 1903.

Frauenverein, St. Paul's Evangelical Church, Hermann

In 1906, the congregation of St. Paul's Evangelical Church voted to build a new church on the site of the old 1844 structure. Kemper seldom attempted interior shots because of lighting problems, but at the last meeting in the old church, he was there to take a picture of the Reverend Henry Bender and the *Frauenverein,* the Ladies Aid Society. He created an extremely strong composition of the members of the society that also records the typical German Protestant style of church adornment. The ladies are wearing their Frauenverein membership badges, and the church is decorated for the final service. The cross on the altar bears the German inscription *Glaube,* "Faith." The pulpit, centered behind the altar, and the encircling balcony, both Old World designs, were not replicated when the new church was built in 1907. The Ladies Aid Society had been organized in 1855, and the streamer reading "1855-1905" commemorates the fiftieth anniversary of the group.

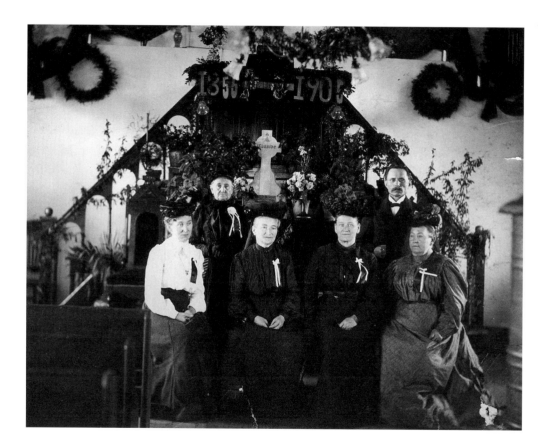

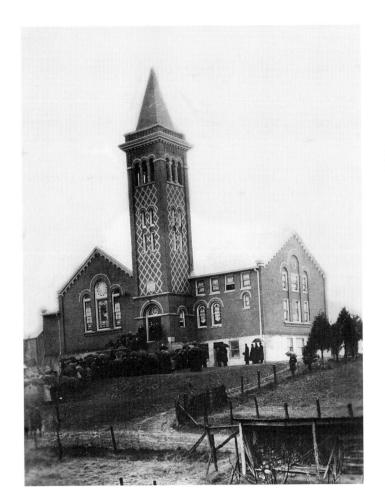

St. Paul's New Church

Because of his knowledge of carpentry and building, Edward Kemper was placed on the building committee for the new church and was involved with all the problems that arose, such as the design of the arches and the breakage of stained glass windows in shipment from Kansas City. Finally St. Paul's Evangelical Church was finished and dedicated on a rainy, cold December 22, 1907. Edward's pride and joy was the north window, *Rock of Ages,* and the new pipe organ. The left window was dedicated to the Eitzen family; the center one, which was broken upon arrival and had to be replaced, was dedicated to Henri and Kathi Walker. The right window was given anonymously; its inscription reads *"Gottbekannt,"* "Known to God."

The church council sat in the first row of seats on the north side and would breathe an "Amen" into their hats before they sat down. The young people, as well as the older ones, all spoke and understood German, and services were held in German. During the service, the women sat on the south side and the men on the north side. In the center section, between the two aisles, the brave, more modern, men and women sat together.

Erin Renn has noted that the Italianate architecture of the new sanctuary of St. Paul's Evangelical Church is unusual for a German community, but the rooster weather vane atop the church is typical of hundreds others across Germany.

Church Choir on Fishing Excursion

According to Edward Kemper, the choir of St. Paul's Evangelical Church was organized by young men and women in the spring of 1899. At first they ran into some difficulty in getting permission to hold practice in the church. Some of the trustees were opposed to the idea, very likely thinking that the young people just wanted a meeting place to have a good time, so the youths were told they would have to furnish their own stove wood. But the church members enjoyed the singing, and interest in the choir grew; by the time cool weather came, the choir was so well liked that they were told they could use the congregation's wood. They were asked to sing every other Sunday, and in a few years had a membership of forty-five. The choir practiced after church every Sunday and then often went for a picnic or a ride in the country together, enjoying both the music and the social activities that followed.

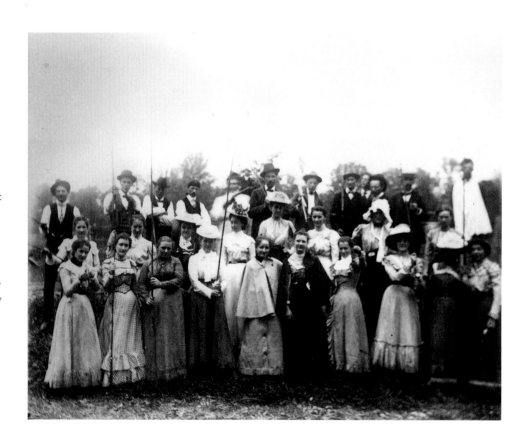

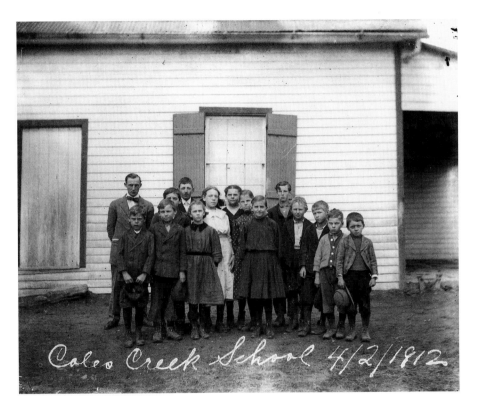

Coles Creek School 4/2/1912

Coles Creek School

The one-room Coles Creek School, built in 1874 adjacent to the Kemper farm, sometimes had as many as sixty children, ranging in age from six to twenty. It was always important to German communities to see that girls as well as boys be educated. The building was heated by a large woodstove located in the middle of the room. Drinking water for the students came from a cistern pump, which had a metal cup attached. It was not until 1914 that the State Department of Education issued a policy statement on common drinking cups, advising school officials that the time had come "in our state when an open bucket and common drinking cup should no longer be tolerated."

Edward Kemper got his early education at Coles Creek School; his daughters also attended the school, and he served on the board for a number of years.

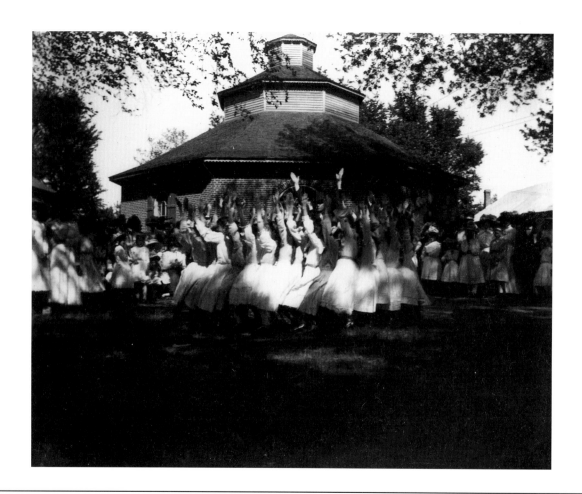

Maifest at the Rotunda

The Gasconade County Agriculture Association was reorganized in 1876, and 6.11 acres of land were purchased by the association. Several buildings were erected on the site, including the octagonal Rotunda, built by artist Edward Robyn. When the structure was completed, it was found that the many posts used to support the roof were inconvenient, and shipbuilder and architect Johannes Bohlken found a way to provide the necessary support with a single center post. Bohlken also designed the cornice of the St. Charles Wine Hall (now The Landing), at that time owned by Fritz Langendoerfer. Bohlken was also responsible for the ornamentation on the pedimented gable of the Pommer-Gentner House, now a part of Deutschheim State Historic Site.

An annual fair was held on the Agricultural Association grounds in September, and about five hundred dollars was allocated for awards.

Prizes were given for different varieties of grapes, wines, and grain; domestic arts were also recognized. There were prizes for best knitted stockings, darning, crocheting, quilting, homemade calico dresses, buttonholes, embroidery, and examples of Holbein technique, a modern revival of an outline embroidery often seen in Holbein's paintings. In 1861 the Missouri Pacific Railroad scheduled a Sunday "Grand Excursion" from St. Louis to Hermann for the event. Admission to the fairgrounds was included in the $2.25 fare.

At Hermann's Maifest celebration, held at the end of the school year in May, children and their teachers paraded from the German School on Fourth and Schiller Streets to the fairgrounds. There they were served *Knackwurst* and pink lemonade (made pink by the addition of a little red wine) and spent the afternoon playing games.

Maypole Dance

At the Maifest picnic in the city park, costumed girls with flowers in their hair danced around a Maypole, one of many Old World customs that survived at the turn of the century. The pole here has a traditional North German leafy tree top. The dance is derived from the ancient ritual of the revival and the awakening of life, the ushering out of winter from the community.

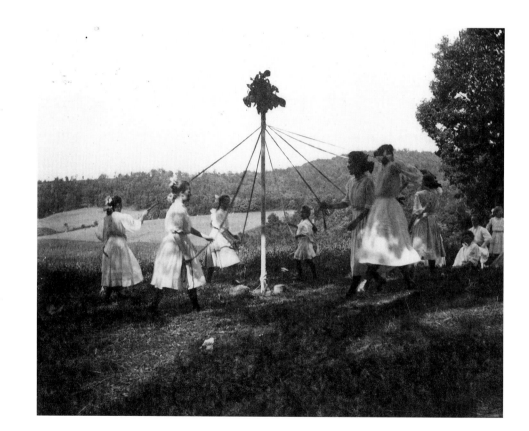

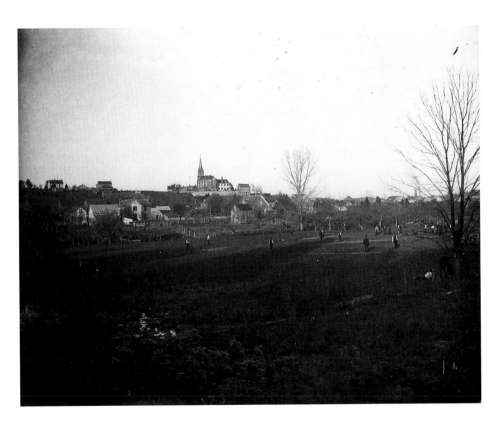

View of Hermann from Field

Taken from the south, this photo shows the old St. George Catholic Church. In the foreground, men are playing baseball in the city park. In addition to their traditional social activities, German Americans enthusiastically celebrated U.S. holidays—especially the Fourth of July—and adopted popular sports. Many German American communities organized recreational baseball teams.

Women Posing on Market Street

This view north on Market Street from Fifth Street shows several of the brick vernacular buildings with cast-iron balconies and door/windows opening on them. The small white cottage at left center is at the corner of Fourth and Market. Most of these buildings are still standing. Rails for tying horses can be seen, as well as overhead electric and telephone lines.

The women are having a grand time, smiling for their photograph, right in the middle of the street. The shadow of the photographer can be seen in the lower right corner.

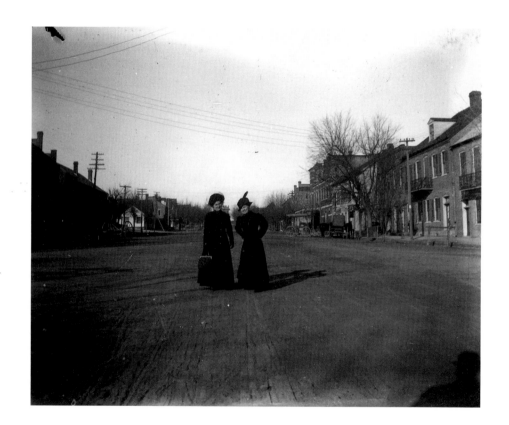

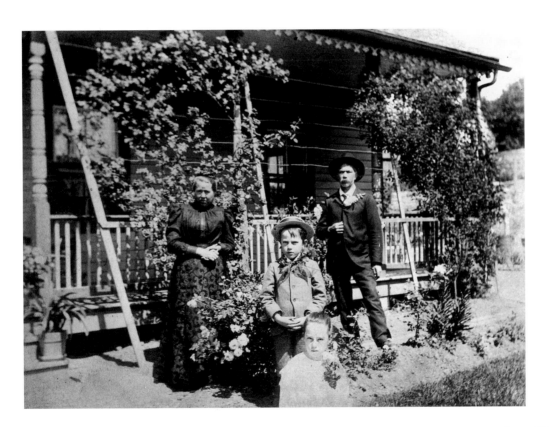

The Bock Family

Members of the Bock family
pose in their yard on Third Street
in 1901. The eave of the house
shows the typical German trim
work. The leaning trellises sup-
port both grapevines and flower-
ing vines. Mr. Bock and his
daughter are wearing corsages to
have their photographs made.

Alice Bock in the Garden

The daughter Alice poses among the flowers in the garden. The strongly composed image, with the young woman repeating the verticals of the tree and the board-and-batten shed, shows a typical German garden with vegetables and flowers freely intermingled. The herringbone brick walk and stone retaining wall are also German touches.

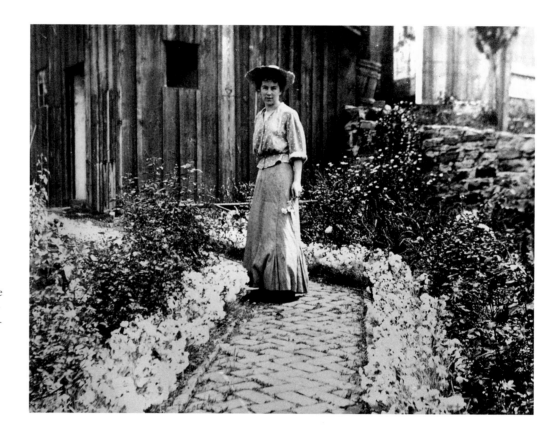

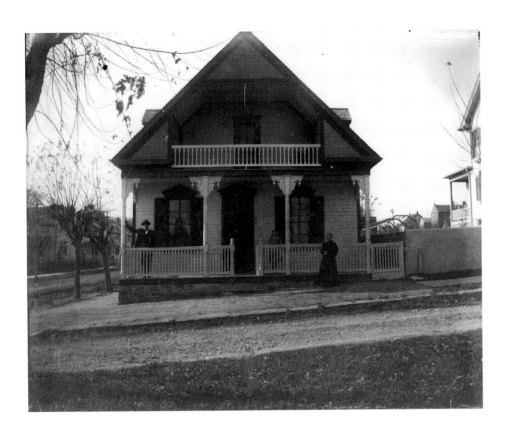

The Epple-Stoehr House

The charming small Epple-Stoehr house at the corner of Third and Market was built in 1895 for Elizabeth Epple, who with her sister Mary was a successful dressmaker. The house, on a corner lot and built to the sidewalk on the street elevations, is the only extant example of chalet influence in Hermann's varied architecture.

Laura Stoehr with Doll

Kemper's niece, Laura Stoehr, holds her doll and poses in her Sunday best. Her mother had died a few months earlier, which could account for her sad expression. The Star Chain Pump above the cistern was made in Gerald, Missouri.

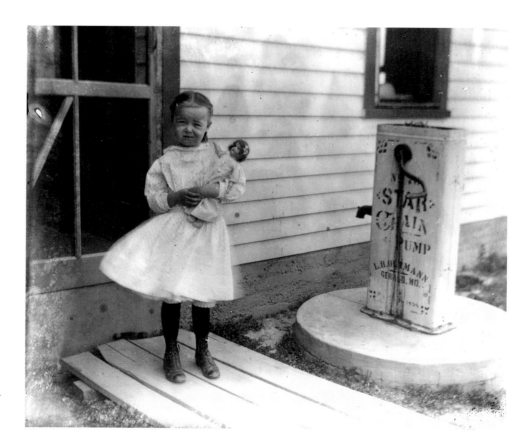

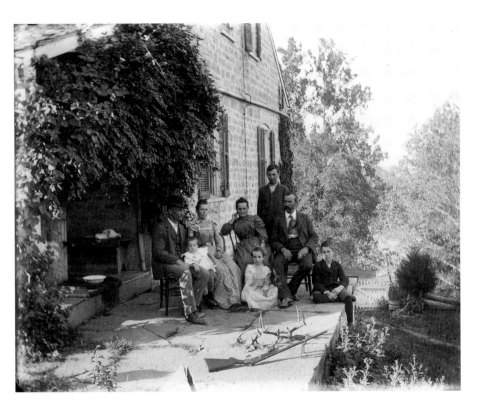

Fritz Gaebler Family

Note the healthy wisteria on the handsome Gaebler house and the antlers and rifle in the foreground. Few except the nobility could hunt in Germany, and immigrant settlers were proud of this aspect of their new lives.

At the time this photograph was taken, the Gaebler family, like others in Hermann, had survived many hardships and were enjoying the peace and comfort that they and their parents had won in "Little Germany."

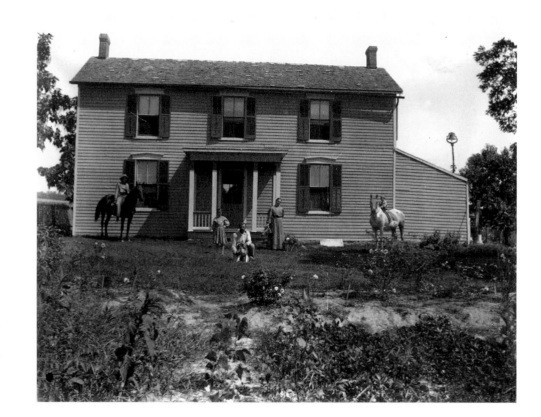

Estes House at Drake

For this photograph Kemper carefully placed the family to repeat the strict symmetry of the house. Even the bell on the pole to the right does not ease the rigidity of this simple, effective composition. Again, a family of immigrants is proud of its achievements—a sizable house, two riding horses, and above-average prosperity.

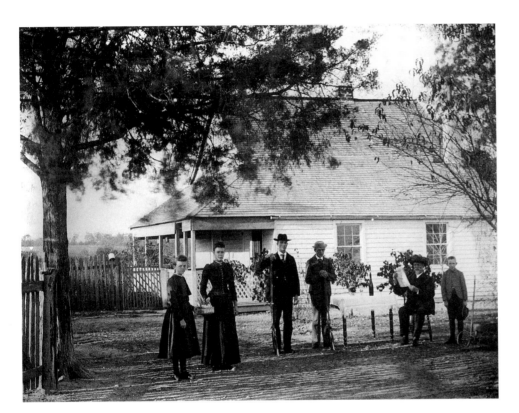

Symbols of a New Life

Family members proudly show off the symbols of their lives. Note the red wine: *Wein ist die Milch des Alters* ("Wine is the milk of elders"). The house, the hand-split picket fence, and the cedar trees set against a vista of cleared fields all suggest the pride and permanence of this German American family. The father reading, the wine bottle and filled glasses on the lace-trimmed table, and the young men with guns connote a bountiful life not possible in the Germany they knew.

A Country Home

The well-kept country homes and the well-dressed families in the Kemper photographs reflect the prosperity of Hermann's golden age. The large L-shaped house could accommodate two families. Note the German placement of chimneys, one centered on the L, and two inside the walls of the main house. The photographer joined the family for this picture.

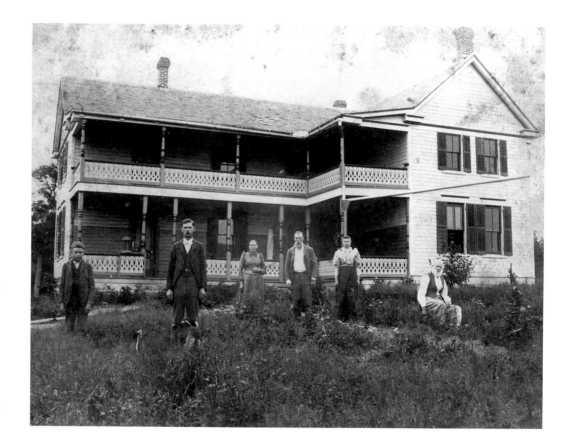

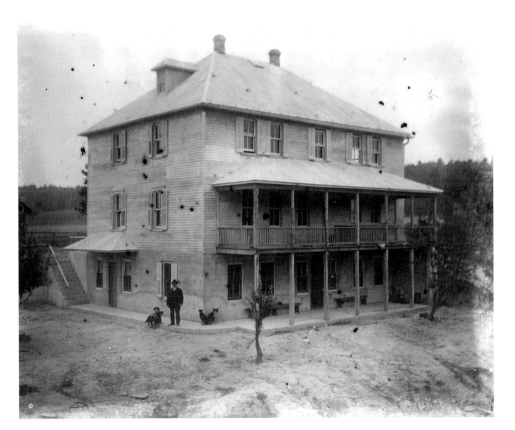

Buschmeyer House

The residence of Charles Buschmeyer Jr. was pictured in the 1913 *Standard Atlas.* The exceptionally large house with its stone ground floor and dormered German hipped roof had a ballroom on the third floor. Sometimes at dances the guests were reluctant to leave, and a broom was brought in to sweep them out as the final tune was played.

Covered balconies, though rare in Germany, were adopted in German American communities in Missouri because of the relief they offered from the summer heat.

Monje House

The gable and Queen Anne detailing incorporate German design elements with a sunburst effect and decorated pierced work. Note the string trellis on which climbers were trained to help cool the porch. The photograph was taken for the 1913 *Standard Atlas.*

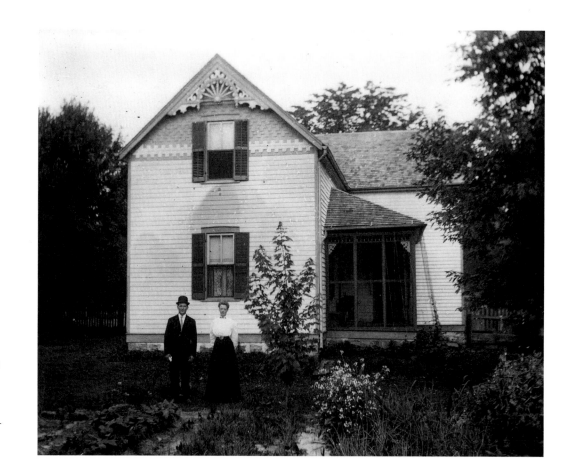

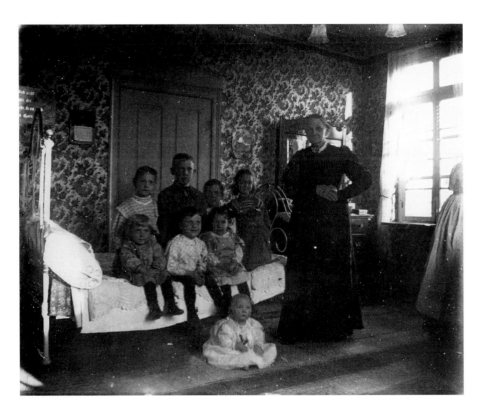

Children on Bed

The florid wallpaper, the handcrafted door, the locally woven rug, and the German house blessing in the room were all typical of German American interiors. This unidentified family had an up-to-date household; gas light fixtures can be seen at the top of the photo.

Seventy-fifth Anniversary Celebration

This postcard scene, dating from 1911, cele-
brates the seventy-fifth anniversary of the
founding of the Philadelphia Settlement
Society, whose members settled Hermann. Like
most German Americans, Hermann residents
demonstrated their patriotism not only on the
Fourth of July but also on other occasions. The
dates promote the annual agricultural fair.

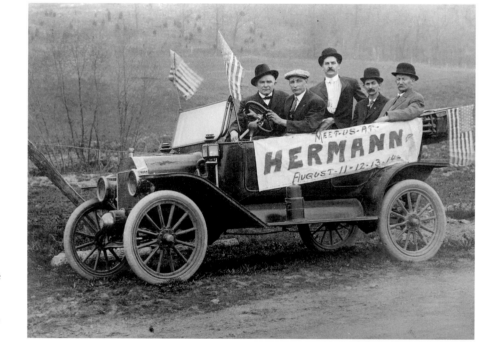

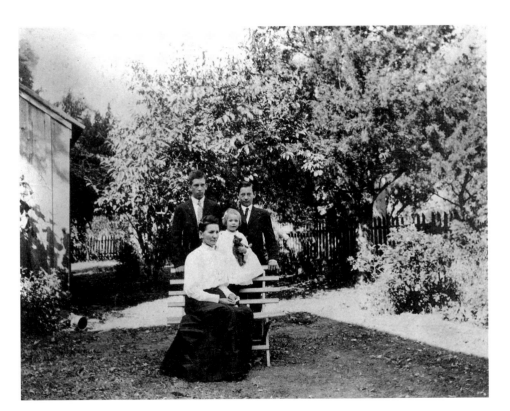

Garden in Swiss

The Frank Gaebler family posed for the camera in the quiet garden behind their store in Swiss. The German American backyard garden was a carefully tended refuge for the family.

Kemperhof in Summer

The Kemper farm, viewed across a field of oats, shows vestiges of a former square of buildings facing across a farmyard, very much in the German manner. The arrangement of the farm has a resemblance to the present-day arrangement of the Kemperhof in Schoenemark, Germany, still operated by a descendant of Toens and Anna. In this photo, however, more recent buildings, such as the packing house nearest the camera, break free of the old German land-use pattern.

Note the colored shingle patterns on the house and the narrow footbridge across the creek, left of the packing house.

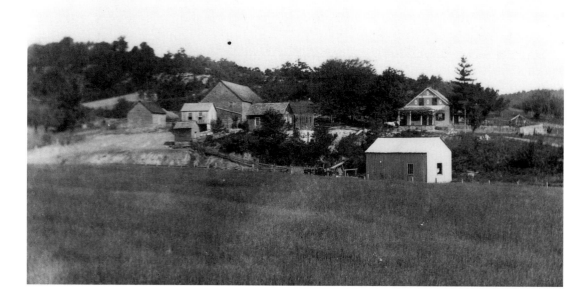

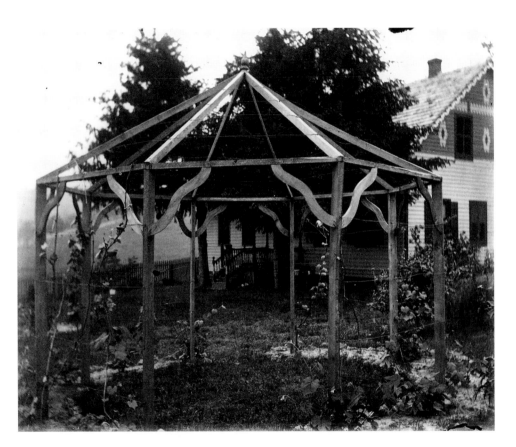

Kemper Grape Arbor

The grape arbor designed by Edward Kemper and built in his side yard as a sales tool and demonstration for growing a variety of grapes in a limited space, can just be seen on the right in the previous photograph. In summer the arbor became a leafy retreat, and Kemper family and friends often gathered around to sample Kemper wines.

The Kemper home's colored shingle patterns and curly eaves trim show well here, giving a Swiss Chalet effect. Varicolored tile patterns appealed to Germans. They can be seen all over central Europe and were brought with immigrants to the United States.

Edna Kemper

Young Edna, who was born in 1903, is shown against a double-heart picket fence, flanked by a handsome weeping mulberry. The photo offers interesting contrasts between the horizontal lines of the bench, the verticals of the fence, and the sweeping curve of the tree with Edna as the counterpoint of the composition. The large yard at Kemperhof was enclosed by a picket fence, which had 1,125 pickets, painted white (and counted) by Henry Salzmann.

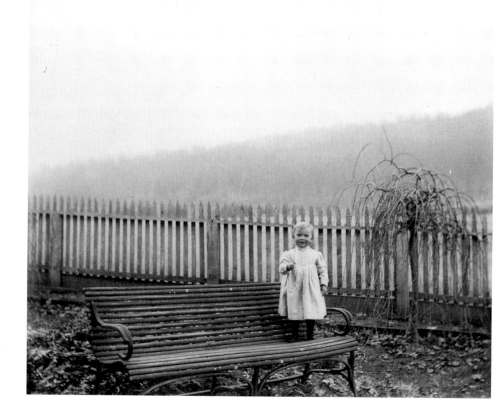

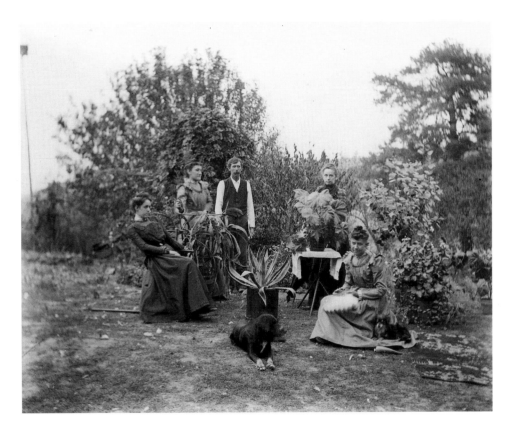

The Naegelin Family

Visiting among neighbors was a favorite activity on Sunday afternoons in the country. This scene at the Naegelin home includes some exotic houseplants set outside for the summer. The family dogs and an apple tree round out the composition.

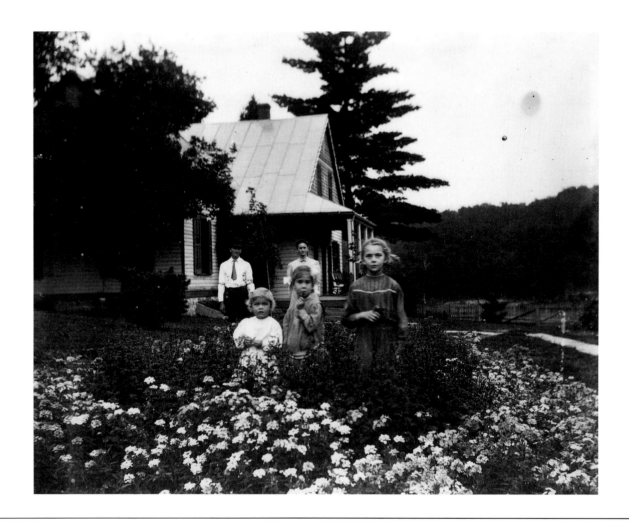

Kemper Family in the Garden

Edward Kemper was a dedicated horticulturist and grew a wide variety of plants in addition to grapes. The Kempers' three daughters stand amidst a bed of verbenas with their parents and home behind them. The children enjoyed the many flower beds. In her father's college notes, Anna Hesse later found the advice he had taken to heart: "Always have beauty around the home with flowers."

German was always spoken in the family when the children were growing up. A German grace was said at each meal, with the youngest always called upon to say grace for family and guests. The children learned hymns and such songs as the round "O wie wohl ist mir am Abend" and "Schön ist die Jugendzeit." Edward Kemper frequently went about his morning chores singing his favorite song, "Die güldne Sonne":

> *Die güldne Sonne voll Freud und Wonne*
> *bringt unsern Grenzen mit ihrem Glänzen*
> *ein herzerquickendes, liebliches Licht.*
> *Mein Haupt und Glieder, die lagen darnieder,*
> *aber nun steh ich, bin munter und fröhlich,*
> *schau den Himmel mit meinem Gesicht.*

> The golden sun, full of joy and delight,
> brings with its rays a heart-refreshing lovely light.
> My head and limbs were in repose,
> but now I rise, lively and happy
> and Heaven is in my eyes.

A favorite saying of Edward's, often heard in the Kemper household, was *"Morgenstund hat Gold im Mund"* ("The morning hour has gold in its mouth"); a more pragmatic, less poetic English equivalent is "The early bird catches the worm." Another proverb he often cited was *"Arbeit macht das Leben süss"* ("Work makes life sweet"), but he never added the second part of the saying within earshot of the children: *"Faulheit stärkt die Glieder"* ("Laziness strengthens the limbs"). Sometimes he was moved to say *"Aller Anfang ist schwer"* ("Every beginning is difficult") or *"Was der Bauer nicht kennt, das frisst er nicht"* ("What the peasant does not know, he won't eat"). German sayings and songs were very much a part of Kemper family life.

A Family Christmas

The parlor was closed off for about a week before Christmas; then on Christmas Eve the children were allowed in to see the tree, decorated with glass bells, balls, homemade garlands, angels, and a few wax candles. There were a few gifts under the tree—not many— but the highlight of the Christmas celebration was gathering around the organ and singing German Christmas songs. The Christmas message in German script reads: "Today the Savior is born to you."

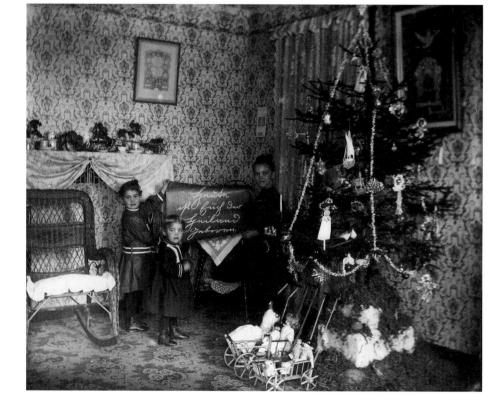

Happy New Year

Kemper made Christmas and New Year cards with his photographs to send to relatives, friends, and customers. In this card, dating from 1912, he sends a bushel of good wishes to all. Hermann may have had a mild Christmas in 1912, or the children may have posed for the photographer earlier during a mild spell of winter weather.

The family attended church on the last day of the year for what they called "Old Year's Eve" services. Afterwards, adults visited and children played games in the church. As midnight approached, the congregation gathered to sing in the New Year.

The Kemper Girls Hoeing Beans

With the arrival of spring and summer, farmwork started again, and children worked with the adults in the garden and in the fields. The need to work was learned at an early age and handed down from generation to generation. Here Edward Kemper's three daughters, perhaps just home from school in their simple cotton dresses, work in the garden.

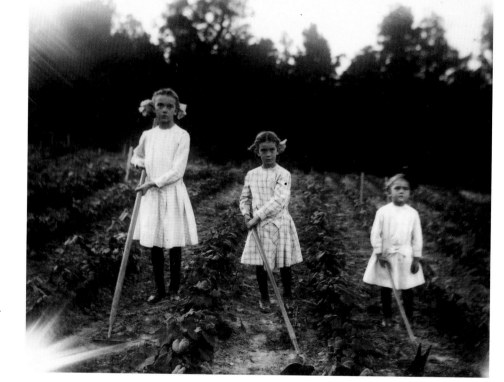

Afterword

Edward Kemper's World

ERIN MCCAWLEY RENN

The German cultural continuance revealed in Edward Kemper's photographs of Hermann runs deep. It permeates Kemper's pictures, and Anglo-Americans would have immediately noticed the difference in visiting Hermann. True, people's clothing, their buggies, and their automobiles were the mass-produced American articles. But study the buildings, the gardens, the arrangements of backyards and farmyards, and similar reflections of the daily lives of Kemper's German American neighbors, friends, and relatives, and a different impression emerges.

An important aspect of German American communities that has been somewhat overlooked in the past fifty years is the fact that although German Americans regarded themselves as Americans to the core (many of them died in America's wars demonstrating their loyalty to their new land), they continued to stay in touch with the homeland of their ancestors, which few of them ever saw. They subscribed to illustrated periodicals published in Germany and

were conversant with changing tastes and trends in Central Europe. Although the Kempers and their neighbors were not themselves on the cutting edge of artistic or intellectual movements in Germany, the influences of their inherited traditions and their connections with Central European patterns current at the time can be clearly identified in the remarkable photographs Anna Hesse has collected and arranged. Kemper's fascination with new inventions, his appreciation of the contrasts between old and new technology, his pleasure in recording his neighbors' latest, most modern, acquisitions led him to photograph scenes that have resulted in some startling juxtapositions. Additionally, his willingness to record special events has left us with many pictures with what are now fascinating backgrounds but which then might have been too old or outdated to interest him were it not for the people in the foreground when he snapped the shutter.

Despite the numbers of traditional German half-timbered build-

ings that still survive, concealed now behind various forms of siding, only two photographs in the Kemper collection show these distinctive structures—one a gristmill, which was never covered with lap siding (a practice begun many years after these buildings were constructed, apparently to make them less "foreign" and more American), the other a barn built by Christoph Kemper, which was revealed as half-timbered as it was in the process of being dismantled. The mill and barn reflect a construction heritage that persisted for many generations into the 1930s, a traditional European form brought to Missouri by rural Germans and widely used in the early settlement years for buildings of all types. Even those settlers who learned how to put up log houses from their Anglo-American neighbors used the familiar half-timbered building techniques when they later enlarged their homes. Others, comfortable with what they had grown up with and not wishing to abandon the old practice and all it represented, built half-timbered barns, mills, and many other structures as much like the ones they remembered as they could. They taught their children and children's children how to build with the ancient mortise and tenon techniques, and this aspect of the German heritage persisted through the hard times (for Germans) of World War I and World War II.

Both half-timbered buildings shown in the photographs, the shabby, abandoned, water-powered grist mill (made obsolete by the widespread adoption of steam-driven roller mills in the 1860s, forty years before the photograph was taken)

and the large Kemperhof barn, shorn of its roof and siding, its bones fully exposed, demonstrate unequivocally that their original designers learned how to construct a half-timbered building in northwest Germany. The grid pattern of the vertical and horizontal elements and the spacing, angle, and placement of the braces rising from the sill to the plate all reflect the heritage of that region.

Another interesting element revealed in the stripped barn is the presence of thatching poles across the entire roof area. Though the barn was shingled in its later years, the presence of thatching poles is a powerful argument for another traditional construction technique. Before the widespread acceptance of mechanical reapers, invented in 1849 by Cyrus McCormick but not in general use until the 1870s and 1880s, cereal grains such as wheat, rye, and barley were raised as much for the long straw the old varieties produced as for their seed heads. Many home industries, from thatching to making the narrow braided strips that were used in manufacturing straw hats (to name only two of the host of uses), depended on this long straw. But when reapers were used, they smashed and mangled the straw in the cutting process and so grains with short stems were developed. Thatching was made obsolete by mechanical reapers. Though some traditionalists from Pomerania, resettled north of Milwaukee, continued to thatch buildings, most Midwest German farmers abandoned the practice. Despite thatch's superior insulating qualities, split shingles (also cheap, as straw had been, and readily available) were in

wide use for houses soon after the Civil War, as an 1870s panoramic photograph of Hermann demonstrates. However, since buildings were often totally retopped after fires or windstorms damaged roofs, it is now difficult to say how many may have been thatched. A large number of present roofs on Hermann's older buildings are replacements, joists and all. Any indications of thatching poles would have disappeared a long time ago.

A handful of early buildings retain the mortised and tenoned joists of the roof beams, nesting into one another at right angles at the apex and pegged into place. This is an ancient technique of securing a roofline without having to resort to metal nails; a builder could make wooden pegs, but he had to pay cash for metal nails. Habits of thrift plus a preference for tried and true older ways made the choice between pegs and nails easy.

Another characteristic imported from Germany is the inclusion of a hatch on house roofs. These hatches provided easy access to the roof and were a practical response to the frequent fires caused by sparks drifting out of a chimney and landing on thatch and wood shingles. The hatches are beginning to disappear now as owners remove them when the building gets a new roof, but a drive through Hermann's alleys will show many still with us.

A law imposed in many German countries required a stone foundation when constructing a building. The law codes regulating the improved longevity of buildings of any kind, but particularly half-timbered ones, came about in the seventeenth and eighteenth centuries as a result of the thinning and disappearance of formerly massive forests. As a wood preservation practice this made sense, and Germans continued to support their structures on stone bases throughout the United States even when there was no legal requirement to do so. These stone bases are one of the identifiers of German design, formal and informal or vernacular.

Other German building habits and preferences are reflected throughout Kemper's work. The prevalence of settlers from northwest Germany can be seen again and again in the roof angles, the pitch of a true forty-five degrees, which lent itself in house or barn to later extensions from a second or third story in a straight run to cover additions on either or both sides as the owners' space needs increased. Another design element that should be mentioned can be seen on both the Gaebler House and the newly consecrated tin-sided church at Bay: the angled soffit return under the eaves (on the church, the steeple eave), coming into the side of the building at a forty-five-degree angle. This is a common characteristic in many parts of Germany, particularly along the lower Rhine north of Cologne, as is the bell-cast eave (an eave with an upward "kick" at its outer edge, created by shims on the rafters), which can also be identified on some of the buildings in Kemper's pictures.

Builders in Hermann were also fond of hand-carved double doors, creating distinctive raised panels and an astragal to

cover the center gap between the two halves. These are identical to those of Westphalia, Hanover, and Lippe-Detmold, reflecting the specific origins of the builders who made them.

Sometimes it is the trimwork on the buildings that most clearly announces their German builders' origins. Intricately carved and scalloped eave boards and similar porch trimming, often with pierced work, are a later nineteenth-century house adornment with roots in German folk art. These traditions came to the United States with immigrants from Switzerland, south Germany, Franconia, and other regions with an active woodworking heritage. English bargeboarding lacks the proliferation of forms and individuality from house to house that distinguishes these German decorations, and the English tradition is for a much wider band of trim. Working-class German Americans were not affected by the influential books of Andrew Jackson Downing and his design colleagues on the inclusion of lacy, intricate, essentially naive trim; they preferred their own decorative traditions brought with them from the Old Country.

A number of structures are covered with board-and-batten siding, the battens chamfered and carefully finished with a level of craftsmanship and attention attesting to their builders' heritage and their deeply held conviction that they were building for the ages. Sometimes the board-and-batten area is restricted to the upper floors or the end walls within the vee of the roof, ending with a distinct overhang lapping the lower walls' surface; sometimes the entire building is board-and-bat-

ten. The characteristic overhang of the upper vertically boarded area can be found throughout the German-built landscape, wherever this construction technique survives.

Other German imports include the wood grills that covered basement or other windows not normally glassed. In these grills square billets are set at an angle, sharp edges facing out and toward each other, to best utilize their protective capacity, a technique in use in Central Europe for hundreds of years. Picket fences, though they do not seem to have as ancient a heritage, were also made just like the ones at home. The double heart pickets were preferred by German American householders, who erected them all across Missouri to be both functional and decorative—they kept livestock out of gardens and looked nice while doing so.

A passion in Germany for what became known in the United States as "Queen Anne" trim (there it was known as "Historicism") had its reflection in the buildings of German Americans. The multicolor paintwork inside and out, the elaborate sunbursts, scalloped or diamond shingle work, and open "carpenter Gothic" grillwork and pendentives that decorated the eave peaks on many houses built from about 1880 to 1915 in this country can be traced directly to Germany for their inspiration. The German middle class became attracted to peasant design elements borrowed from German Swiss chalets, sixteenth- and seventeenth-century carved fancywork, and decorative folk art building trim. From these they created a new design mix that had a major impact on housing design at all

social levels in Central Europe and in the United States. Even Walt Disney helped popularize a romantic Germanic architecture in *Snow White and the Seven Dwarfs*. For German Americans this influence was augmented by journals and illustrated monthly magazines published in Stuttgart or Leipzig or Berlin. Kemper's photographs show a number of neighbors' just-built houses with the simplified Germanesque trim typical of the era, the proud householders lined up in front surrounded by other symbols of the affluence achieved in America.

Another aspect of German house design not as widely adopted, or perhaps more frequently altered over the years, can be seen in some of the photographs of the Kemper home. The painted shingle patterns can be seen on the east end of the house, patterns that emulate in paint the geometric patterns in colored slate tiles characteristic of many medieval German and Austrian churches and palaces, and that were adopted as part of the overall body of ethnic design popularized in Germany from the 1860s on. The style was picked up abroad after the German victory in the Franco-Prussian War of 1870–1871, which was much applauded in the United States, as it was going through an anti-French phase. (Even the U.S. Army was affected. For a time the cadets at West Point wore the *Pickelhaube,* or spike-topped helmet, now so associated with negative aspects of World War I that it has become a symbol for aggression.)

The tidy brick cottages and houses of Hermann are particularly German in spirit. The early neoclassical designs, interspersed with the more numerous and usually larger German vernacular houses built from the 1850s through the 1910s, had their analogues in Germany as well. Most of the Central European cottages and smaller houses have disappeared, remembered only in paintings, drawings, and photographs; they gave way before urban expansion and the destruction of wars in Europe, and, being laborers' housing, were not duplicated elsewhere (peasant half-timbering has been cherished for generations in Europe, but not the housing of the urban poorer classes). Kemper's work has thus recorded something once common in Germany and in the Midwest, but that now survives only in significant numbers in Hermann, where these small neoclassical and vernacular houses are still an important element of the built landscape, truly survivors of a German building style no longer common in the home country.

Casement windows, the design of choice in Central Europe, can be spotted in many Hermann buildings. Tiny attic windows became casements by hinging one half of a stock double sash, which turns it into a little glassed door that opens inward. Chimneys tend to be centered on a roof to serve two or three flues; when a building was too large for this technique, the chimneys, still serving more than one flue each, were incorporated flush into end walls. They were not applied to the outer wall in the English and Anglo-American manner.

Most German-settled areas in the Midwest can be identified from a distance by the German preference for octagonal steeples that tower over the front entrances of their churches.

Other elements of church architecture were also successfully transferred. The 1905 interior of the old St. Paul's Evangelical Church, of which Kemper was a member, reveals a scene that could have been transposed directly to any similar church in Germany without alteration. The wreaths, the swagging, the design of the altar and pulpit, the galleries on either side, and the white walls and dark wood are identical to illustrations of Evangelical churches in German books of the period. Religious bodies are noted for their preservation of culture and their stabilizing influence on their members. Whether Catholic, Lutheran, or Evangelical, the formal churches changed slowly in the New World, and the interior organization and decoration of the church, as well as the German hymns and German language services, were a key element in holding its members to the values and traditions of the past. The extent to which the churches succeeded can be measured by the persistence of German-language church services and German gravestones in cemeteries up to the onset of World War II.

In the original part of Hermann, captured in many of Kemper's photographs, the houses and shops were built directly at the front of the lot in the European manner to leave as much space behind as possible. German preferences for neatness can be seen in the widespread installation of brick or flagstone sidewalks and carefully designed stone curbs and gutters. Even in a small, not terribly affluent town like Hermann, a high level of civic pride and care can still be traced. All the original lots were 60 by 120 feet, with the back

of most lots abutting an alley, which in many German communities became subsidiary streets. Formerly, many Hermann residents used part of their small backyards for livestock: chickens and geese, a pigsty, perhaps a beehive, and a cow or horse. They also gardened intensively, using dense mixed plantings of vegetables and ornamentals. Some left no ground unproductive, cramming an array of fruit trees, berry bushes, arbors of wine grapes, and annual plantings onto their garden patches. Only narrow paths quartering the whole would be left for permanent access. Some residents of Hermann, letting others do the vegetable gardening for them, while maintaining the fruit trees, berries, and asparagus beds, gradually converted their limited space to more decorative and less practical plantings. An excellent idea of the intensity of their planting can be seen in the photograph of Alice Bock, standing beside her father's house, surrounded by a lush profusion of vegetables and flowers freely mixed together in the brick-edged beds.

The passion for plants can be seen in the country scenes as well, with families standing proudly amid their large gardens or sitting next to treasured houseplants, carefully placed outside for the summer. The appearance of grass maintained as lawn in some photographs speaks to the increasing affluence of German Americans in Hermann, mostly the children or grandchildren of impoverished emigrants who, had they remained in Germany, would never have achieved such an amenity. Kemper himself was addicted to plants, a profession-

al horticulturist, who for fun raised exotics at Kemperhof—weeping figs, bananas, and citrus trees, which today we do not associate with Missouri backyards at all.

Through his many interests reflected in his photographs—rich in detail, comprehensive in scope and variety, life-affirming and imaginative—Kemper leads us into the world he knew and loved. From arched bridges, stone built and stone buttressed, to the ancient ritual of Maypole dances welcoming spring, he documents German cultural traditions transplanted to Missouri and maintained for generations. Many survive only in his images.

The founders of Hermann expected it to grow into a large metropolis, but by the late nineteenth century not even the most optimistic of the town's leaders could foresee a time when Hermann would become larger than St. Louis, so the city fathers decided to move in a new direction and emphasize the European heritage of Missouri's Little Germany. However, viewing Kemper's photograph of the allée created down Market Street, shown in the snow scene of boys sledding in front of the firehouse and city hall, is about the only way the promenade can be enjoyed today. After the opening of the Missouri River Bridge in 1930 and the subsequent increase in traffic, especially from the 1950s on, the Missouri Department of Transportation redesigned Market Street again. The European-influenced allée has been narrowed by more than forty feet where it survives at all and removed entirely for part of its original reach. While ancient town plans have managed to survive in many parts of Europe despite the internal combustion engine, that kind of historic preservation has not often been part of the American experience. The idea of a midstreet market house or an allée was foreign (and perhaps suspect) to Anglo-American road planners, and their work eradicated these important vestiges of a German cultural past.

Many other aspects of Edward Kemper's world would be lost without his documentary photographs. To his world, founded in church, community, family, and work, and marked by a strong feeling of cultural identity, he brought an affectionate eye, intellectual curiosity, a sense of fun, and a love of beauty in images sometimes amusing, often charming, always true, infused with an aesthetic sense and recorded with a sensitivity that gives them lasting value, not only as documents but as art.

Appendix

The photographs by Edward Kemper appearing in the *Standard Atlas of Gasconade County* (1913) include:

Page 79, Wm. Fricke, Jr., & Family, Hermann, RR

Page 83, Henry Dorsch & Family, Hermann, RR

Page 85, Wm. A. Beckmann, residence, barn, & silo, Hermann, RR

Page 85, Louis Ochsner, Hermann, RR

Page 85, Andy C. Zimmermann, Hermann, RR

Page 85, Bernard Stoecklin, Hermann, RR

Page 87, Paul Keller, Fredericksburg

Page 87, Paul Gaebler, Hermann, RR

Page 87, Edna, Esther, & Anna Kemper, Hermann, RR

Page 89, Store and Post Office, Swiss

Page 91, Louis Ochsner, Deer Park, Hermann, RR

Page 91, Residence & Saloon, Emil Nagel, Hermann

Page 91, Residence of Charles Buschmeyer, Jr., Hermann, RR

Page 91, Residence of Frank Birkel, Hermann, RR

Page 91, Residence of Barbara Dilthey, Hermann, RR

Page 93, Residence of Oscar Loehnig, Hermann, RR

Page 93, Scene on Farm, O. Loehnig, Hermann, RR

Page 93, Scene on Sugar Creek Stock Farm, Hermann, RR

Page 93, Residence of John Schneider, Jr. (former Gaebler place), Hermann, RR

Page 93, Scene on farm of A. Langendoerfer, Hermann, RR

Page 93, Natural Cave Wine Cellar of A. Langendoerfer, Hermann, RR

Page 93, Residence of J. H. Hoelmer, Hermann, RR

Page 95, Residence of Paul Monje, Jr., Hermann, RR

Page 95, Red Polled Cattle, Andy Zimmermann Farm, Hermann, RR

Selected Bibliography

Baudissin, Albert. *Der Ansiedler im Missouri-Staate.* Iserlohn: Julius Bädeker, 1854.

Bek, William G. "The Followers of Duden." *Missouri Historical Review* 17 (April 1923): 331-47.

———. *The German Settlement Society of Philadelphia.* Trans. Elmer Danuser, ed. Dorothy Heckmann Shrader. Hermann, Mo.: American Press, 1984.

———. *The German Settlement Society of Philadelphia and Its Colony, Hermann, Missouri.* Philadelphia: Americana Germanica Press, 1907.

Bülau, Friedrich, ed. *Jakob Naumann's Reise nach den Vereinigten Staaten von Nordamerika, siebenjähriger Aufenthalt in denselben und Rückkehr nach Deutschland.* By Jakob Naumann. Leipzig, 1850.

Coburn, Carol K. *Life at Four Corners: Religion, Gender, and Education in a German Lutheran Community, 1868-1945.* Lawrence: University Press of Kansas, 1992.

Duden, Gottfried. *Bericht über eine Reise nach den westlichen Staaten Nordamerika's und einen mehrjährigen Aufenthalt am Missouri (in den Jahren 1824, 25, 26, und 1827), in Bezug auf Auswanderung und Uebervölkerung.* Elberfeld: Sam Lucas, 1829.

———. *Report on a Journey to the Western States of North America and a Stay of Several Years along the Missouri.* Ed. James W. Goodrich et al. Columbia: State Historical Society and University of Missouri Press, 1980.

Falbisaner, Adolf. "Eduard Mühl, A German-American Champion of Freedom and Human Rights." Trans. Arpy E. Hacker. Photocopy of MS, Indianapolis, Indiana, 1931. Copy in the State Historical Society of Missouri; 124 pp.

———. *Eduard Mühl, Ein Deutsch-Amerikanischer Kämpe für Freiheit und Menschenrechte.* Philadelphia: German-American Annals Press, 1903. Copy in the State Historical Society of Missouri; 80 pp.

Goebel, Gert. *Länger als ein Menschenleben in Missouri.* St. Louis: C. Witter, [1877].

Harrison, Samuel F. *History of Hermann, Missouri.* Hermann, Mo., 1981. 13 pp.

Hedrick, U. P. *The Grapes of New York.* Report of the New York Agricultural Experiment Station for the Year 1907, II. Albany: J. B. Lyon, State Printers, 1908.

Hesse, Anna. *Centenarians of Brick, Wood, and Stone.* Hermann, Mo.: privately printed, 1969. 35 pp.

———. *Gasconade County Tours.* Rev. ed. Hermann, Mo.: privately printed, 1975. 32 pp.

———. *Hermann Maifest Pageants, 1952-1964.* Hermann, Mo.: The Brush and Palette Club, 1980. 188 pp.

Hesse, Anna, ed. and trans. *My Journey to America, 1836-1843,* by Jakob Naumann. Hermann, Mo.: privately printed, 1969. 52 pp.

Löher, Franz [von]. *Geschichte und Zustände der Deutschen in Amerika.* Cincinnati: Eggers & Wulkop, 1847.

Muehl, Siegmar. "Eduard Mühl, 1800-1854: Missouri Editor, Religious Free-Thinker, and Fighter for Human Rights." *Missouri Historical Review* 81 (October 1986): 18-36.

Muehl, Siegmar, and Lois B. Muehl. *Hermann, Missouri, 1852: News and Voices.* Iowa City: privately printed, 1987. 99 pp.

Standard Atlas of Gasconade County, Missouri, Including a Plat Book of the Villages, Cities, and Townships of the County. Chicago: George A. Ogle, 1913.

Stevens, Linda Walker. "Hermann, Missouri: Pearl of Great Price." *Society for German American Studies Newsletter,* June 1997, 12-16.

———. "The Making of a Superior Immigrant." *Missouri Historical Review* 89 (January 1995): 119-38.

———. "The Story of Wine at Hermann." Unpublished TS provided by Stevens.

Van Ravenswaay, Charles. *The Arts and Architecture of German Settlements in Missouri: A Survey of a Vanishing Culture.* Columbia: University of Missouri Press, 1977.

———. *Missouri: The WPA Guide to the "Show Me" State.* Introduction by Walter A. Schroeder and Howard W. Marshall. St. Louis: Missouri Historical Society Press, 1998.

Index

African Americans, 90, 91, 101
Albany, N.Y., 14
Alte und Neue Welt. See Newspapers
Ameling, Charles, 60
American Pomological Society, 84, 85
Anglo-Americans, 41, 59
Apples: varieties of, 7; grafting of, 10
Arolsen (Germany), n33
Aroma. *See* Grapes
Automobile, 78, 79, 80

Bacchus in parade, 82
Baden (Germany), 86, 113
Baecker, Kermit, 45
Baer, Conrad, n17
Baltimore, Md., 14
Baudissin, Count Adelbert von, 81, 82
Bay, Mo., 116, 151
Bayer, George F., 15, 17, 18, 19, 24, 37, 83
Begemann, Armin, 41
Begemann, August, 41
Begemann, Louis, 41, 49
Bek, William G., 13, n14, n18, 19, n24, 28, 116
Bender, Pastor Henry, 118
Berger, Johanna, xvi, 1, 8
Berlin, 153
Berlin Society, 15
Big Berger Creek, 1, 57

Big Hatchie, 43
Blaske, Frank, 45
Bluffton, Mo., 83, 86, 91
Bock, Alice, 128, 154
Bock, Henry, 47, 127.
Bock, Johann Wilhelm, 15
Bohl, Henry, 60
Bohlken, Johannes, 45, 123
Bourbeuse River, 38
Breeding, John, 62
Bremen (Germany), 1, 22
Breweries: Jacob Krobel, 26, 46; J. D. Danzer, 46;
 Hugo Kropp, 46
Bromme, Traugott, 15
Brownie. *See* Camera
Brush and Palette Club, 31
Buffalo, N.Y., 5
Burger, Harry, 45
Buschmeyer, Charles, Jr., 135; house of, 135
Buschmeyer, Karl, 69

California: gold fields, 30, 75; vineyards, 87, 114
Camera, 2, 7, 34, 35
Cherusci, 17
Chiles Valley, Calif., 114
Chimneys, 59, 134, 151, 153
China, 89
Cholera epidemics, 25, 27

Christmas. *See* Customs
Churches, 19, 25; Presbyterian at Gebler, 62; St.
 George Catholic, 52, 55, 125; St. John's at
 Swiss, 58; St. Paul's Evangelical (now United
 Church of Christ), 6, 54, 55, 118, 119, 120,
 154; Zion at Bay, 117, 151
Cigar factory, 37
Cincinnati, 1, 14, 18, 23, 81, 113
Civil War, 27–29, 45, 75, 150
Cleveland, 14
Coles Creek, 5, 94; road, 69; school, 1, 3, 121
Cologne (Germany), 151
Concord. *See* Grapes
Concord (ship), 12
Congress, U.S., 14
Cooperage, 47
Cooper trade, learning, 1
Country stores: Feil's, 62; Gebler, 62; Potsdam, 61;
 Stolpe, 59; Swiss, 58
Courthouse, Gasconade County, 22, 27, 51, 54, 55
Crawford County, 38
Customs, 122–24, 135, 147, 155; Christmas, 146;
 death, 116; religious, 115, 116, 117–19, 137,
 145

Danzer, J. D., 46
Deere, John, 7
Denman, David, n87